Modern Architecture in Theatre

DOI: 10.1057/9781137368683

Also by Gray Read

ARCHITECTURE AS A PERFORMING ART (*edited with Marcia Feuerstein, 2013*)

THE MINIATURE AND THE GIGANTIC IN PHILADELPHIA ARCHITECTURE: Essays on Designing the City to Human Scale (*2007*)

DOI: 10.1057/9781137368683

palgrave▸pivot

Modern Architecture in Theatre: The Experiments of Art et Action

Gray Read

Associate Professor of Architecture,
Florida International University, USA

palgrave
macmillan

DOI: 10.1057/9781137368683

MODERN ARCHITECTURE IN THEATRE
Copyright © Gray Read, 2014.

First published in 2014 by
PALGRAVE MACMILLAN®
in the United States—a division of St. Martin's Press LLC,
175 Fifth Avenue, New York, NY 10010.

Where this book is distributed in the UK, Europe and the rest of the
world, this is by Palgrave Macmillan, a division of Macmillan Publishers Limited,
registered in England, company number 785998, of Houndmills, Basingstoke,
Hampshire RG21 6XS.

Palgrave Macmillan is the global academic imprint of the above companies
and has companies and representatives throughout the world.

Palgrave® and Macmillan® are registered trademarks in the United States,
the United Kingdom, Europe and other countries.

ISBN: 978-1-137-36869-0 EPUB
ISBN: 978-1-137-36868-3 PDF
ISBN: 978-1-137-36867-6 Hardback

Library of Congress Cataloging-in-Publication Data is available from
the Library of Congress.

A catalogue record of the book is available from the British Library.

First edition: 2014

www.palgrave.com/pivot

DOI: 10.1057/9781137368683

For Marco Frascari

DOI: 10.1057/9781137368683

Contents

DOI: 10.1057/9781137368683

List of Illustrations

DOI: 10.1057/9781137368683

Acknowledgments

This book took form with the help of many colleagues who generously lent their time and expertise, as well as institutions, which offered specific support at critical moments. First I thank the late Marco Frascari to whom I owe much of the spirit of the enterprise and the courage to pursue ideas wherever they might lead. His inquisitive eye and gentle encouragement stays with me. I dedicate the book to him. Financial support was provided at two crucial moments by my home institution, Florida International University (FIU). I enjoyed a fellowship at the Wolfsonian/ FIU museum, where librarian Frank Luca unearthed an extraordinary trove of journals that opened the door from architecture into theatre. I also received a timely grant from the Paul J. Cejas Discretionary Strategic Initiative of the FIU Department of Architecture that allowed me to engage the skilled Damir Sinovcic to develop digital architectural models from archival sketches. Eduardo Luna also contributed to the digital representations. I remain grateful for the support of my department in recognizing what it takes to engage a substantial scholarly project such as this one, in particular Adam Drisin and John Stuart who each served as department chair. In Paris I spent many hours in the Bibliothéque Nationale de France Archive des Arts du Spectacle, where the staff were unfailingly gracious. Caroline Maniaque provided a roof and joyous company. In Washington at the Library of Congress, my aunt Barbara Kraft made photocopies that helped make research at a distance possible. I am grateful to several colleagues who read early drafts and made substantive comments: Paul

Groth, Elizabeth Cromley, William Braham, Paul Emmons, Marcia Feuerstein, John Stuart, and David Rifkind. Don Kunze read a later draft of the entire manuscript and wrote detailed comments well beyond the call of duty. His suggestions and observations were invaluable. Alberto Perez-Gomez, Jean-Louis Cohen, Mary McLeod, and Bernard Tschumi offered encouragement along the way through their publications and in words of support. At Palgrave Macmillan Robyn Curtis took a chance on a book that is a bit outside of the normal purview and has way too many illustrations. Erica Buchman has also been attentive. In the final editorial push I owe much to Nancy Elkund Later who read with a fine eye and good humor, offering myriad suggestions. And finally I am grateful to my family. My husband Philip Stoddard supported me in many ways with grace and understanding, from organizing our lives to include this project to helping me clarify ideas and offering insightful commentary on the manuscript. He, our daughter Vannak, and his parents Ted and Jewell Stoddard have stood by me always and made the process of developing this book a pleasure.

DOI: 10.1057/9781137368683

Introduction: Architecture as a Performing Art

Abstract: *Architecture and theatre have long been allied in creating the characteristic events of the city. In the 1920s Parisian architect Edouard Autant explored the art of architectural design through a series of modern theatrical performances presented by Art et action, a company he formed with actress Louise Lara. Together, they merged British director Edward Gordon Craig's strategies for architectural set design with an approach to performance emphasizing multi-sensual simultaneity. In five types of modern theatre, they created spaces and performances that anticipate the architecture and actions of an ideal, modern city.*

Read, Gray. *Modern Architecture in Theatre: The Experiments of Art et Action.* New York: Palgrave Macmillan, 2014. DOI: 10.1057/9781137368683.

The city and its architecture have often been likened to a theatre, in which we play the roles of daily life, seeing and being seen in a minor frisson of urban pleasure. British theatre director Edward Gordon Craig put it thus, "There is something so human and so poignant to me in a great city at a time of the night when there are no people about and no sounds. It is dreadfully sad until you walk till six o'clock in the morning. Then it is very exciting." When people fill the city, the architecture transforms, as it takes many and various roles in the thousand stories that people play out in their actions. Craig found poignancy in the city and excitement, not in the visual image of the buildings as objects of art but in their potential for drama. In designing sets for the stage, Craig constructed architectural spaces that gave actors positions and spatial relationships that they could use expressively, sometimes in graceful concert and sometimes with physical strain and resistance. Craig brought architecture to the stage out of the city and then returned dramatic narratives to the city, giving back the echoes of many stories. Through his work the dramas of the city accumulated from street to stage and back again in the characteristic events of urban life.

This book centers on the work of architect Eduard Autant and his wife, actress Louise Lara, who seized Craig's challenge to explore the actions of architecture in theatre. They developed a systematic approach to the design of spaces that act with people to spark events.[1] In 1919 they formed an experimental theatre company, Art et action (Art and action), in Paris, where they worked with a group of progressive artists, poets, and musicians to develop performances that spanned the arts.[2] Autant's calling was architecture. "Each drama," he wrote,

> needs its proper scenic situation. To determine this is to envision the means of production that can release the spirit, affirm the character and develop the discussion. The lighting of a painting and the aeration of a statue, to the acoustics of a room, reinforce the primary purpose of the piece, giving it a vital atmosphere, like the fish, bird, worm need water, air, earth—not to be confused with aquarium, cage, and flowerpot.[3]

Autant proposed architectural spaces to create these "vital" atmospheres; specifically, he and Lara explored how spaces place and frame people in relation to each to create distinct kinds of events that could open to creative contact. Autant and Lara's work in the mirror world of theatre addresses the spatial qualities of watching and being watched

DOI: 10.1057/9781137368683

that are integral to the performances of social life. Their experiments in theatre reflect back on the characteristic social events in Paris of the 1920s, the city they knew, and project forward to envision the spaces and events of an ideal city that they imagined for the future.

Autant and Lara merged Craig's spatial sensibility with an artistic philosophy of simultaneity, first articulated by the poet Guillaume Apollinaire, that modern artistic experience is constructed by an active spectator stimulated by disparate, simultaneous sensations and narratives.[4] This approach to art shifted focus away from creating a unified art object and toward giving spectators a multi-sensory field of experience rich with poetic potential. For many artists associated with Apollinaire, including Autant and Lara, modern, simultaneous art was allied with a Marxist political stance, specifically a vision of a collective society in which each person would act according to his or her spirit and calling. Many disparate, creative actions answering the human spirit would coalesce in unforeseen ways to move society forward. Architecture, as an affirmative vital atmosphere, was crucial to artistic events and, by extension, to social events of a new society.

Some of Autant and Lara's ideas emerged into the design of buildings in Paris through the work of likeminded colleagues such as Auguste Perret and Robert Mallet-Stevens, well-known architects who defined modernism along similar philosophical lines.[5] Their approach to design was distinctly progressive yet differed pointedly from the dominant voices then defining modern architecture. Perret in particular, who had been a classmate of Autant at the École des Beaux Arts, designed and built a broad range of public spaces and buildings that supported an urban life of active citizens in a society conceived collectively.[6] He stood in opposition to the version of modern architecture championed by Le Corbusier and spoke his mind in print and through his work.[7] Whereas many modern architects looked to the fine arts for inspiration, Autant, Lara, Perret, Mallet-Stevens, and others offered instead a clear statement of modern architecture as a performing art.

The city as theatre

This study began as a search for architectural strategies that might enhance the social life of the city, a goal that has become increasingly

DOI: 10.1057/9781137368683

urgent for contemporary architects. Building habitable cities that are inviting, efficient, and poetic is key to sustainability. Reviving public space, designing for a changing mix of uses and populations, and creating places for urban life challenge contemporary architects to invent new forms and glean what they can from the beloved cities of the past. Most architects embrace the challenge of urbanity but find few models to guide them. On the one hand, the commercial razz-ma-tazz of shopping districts and staged "communities" revive historical forms such as town squares that no longer function as they once did: the fakeness grates. On the other hand, the dominant, modern tradition that contemporary architects have inherited distains overt "theatricality" and is notably lean on advice for designing urban buildings. Modernists of the mid-twentieth century had so effectively rejected classical design that architecture's long-standing link with the art of theatre grew thin. Contemporary architects are now inventing anew the art of urbane design and are again reaching toward theatre, not for showiness but rather for human substance.

Autant and Lara's work and that of their architect colleagues was squarely rooted in the Baroque metaphor of *theatrum mundi*—that the world is a stage. This deep metaphor, familiar from Shakespeare's *As You Like It*, casts human choices and actions in life as a drama directed and watched over by God within the Globe Theatre of the universe.[8] The world was a large theatre reflected in miniature in the small theatres where actors play roles that reveal the human condition. In the most ancient expression of the tradition, theatrical performances and the theatre buildings that house them were understood as places of vision (Greek: *theatron*) where spectators watch as a god might watch the dramas and follies of human life. Theatres are microcosms that offer a view through to the macrocosm by way of stories. The metaphor also places theatre directors and architects in a presumptuous and potentially dangerous position as pretenders to divine wisdom.

Autant and Lara took up the mantle of both theatre director and architect but constructed a role less as priestly conduit to understanding than as a minister who sets up conditions in which spectators may find their own path. Art et action's performances included many simultaneous elements juxtaposed with each other, so multiple and indeterminate meanings could be creatively constructed by those participating in the artistic caldron of each event, actor and spectator

DOI: 10.1057/9781137368683

alike. Autant and Lara's task as architect and as director was to open a space by means of the performance, so that flashes of spirit might ignite in the moment.

In this sense, the architect's art parallels that of a theatre director. Both work beforehand to contrive the conditions of an event so that it might open to real experience. Whereas the director prepares the actors, so they may perform well in a theatrical event, the architect prepares the place, so that it may perform as a kind of non-human actor in the events of the city. Both anticipate what will happen and plan from a narrative of use—a script or scenario for the director and a program in the case of the architect—yet neither can determine an outcome. They prepare, yet they cannot control events as they unfold. Neither do they act in the events themselves. Director and architect step back. Ultimately, the actor and the building must perform on their own, interacting in real time with people and elements of the scene in the moment. Director and architect may fret in the wings, but they can only watch to see whether the scene takes poetic flight or not. Their art lies in setting up the elements so that that sparks of true contact can fly.

Theatre itself originated in the social events and architecture of the city. Historian David Wiles traces the roots of theatric forms to urban rituals and festivities.[9] Greek theatre arose out of the festival of Dionysus and took place in front of her temple following the ritual sacrifices and dances of the rite. Spectators witnessed the sacrifices and the plays as part of a spiritual communion with the gods and with each other.

Wiles traces another genre of theatre, cabaret, to short entertainments that accompanied feasts, which were often hosted by a king or noble-man in the main hall of his manor. Songs, clowning, and feats of skill filled the time between courses amidst the dining tables, while a master of ceremonies kept up a patter and guests added witty commentary. In sum, Wiles found that each theatric form holds a distinct character and place in the city, and each depends on a distinct relationship between those who act and those who watch.

Most social events incorporate an element of theatre, in which some people perform while others watch. Catholic mass, for example, is a highly choreographed performance with symbolic costumes and fixed roles. The narrative of communion is always the same, yet its very repetition draws the congregation together in ritual. An urban festival, on the other hand, such as Carnival also has choreography and costumes, yet it

DOI: 10.1057/9781137368683

includes many stories and spontaneous performances that take place all around spectators, absorbing them in the general festivities. Everyone sees and is seen simultaneously.

The historical give and take between theatric events and social events informed the architecture of both. The depth of this tradition is probably best expressed in drawings published by Sebastiano Serlio in his sixteenth-century treatise, *Tutte L'Opere D'Architettura et Prospetiva* (*All the Works on Architecture and Perspective*). Serlio distinguished three types of theatre: tragedy, which took place among kings in the city's public square; comedy, which revealed the foibles of nobility in the private rooms of palazzi; and farce, which took the form of Saturnian romps in the woods.[10] The balance of Serlio's treatise follows the same logic: that each aspect of life (such as worship and dwelling for example) should take its place architecturally within an orderly city. An architect's role was therefore to design the city and its elements with proportional precision to elevate the theatre of social life in each of its aspects to create a unified, urban entity.

The classical, theatric tradition of architecture instructed by treatises such as Serlio's became increasingly codified through the eighteenth and nineteenth centuries, particularly in the French École des Beaux Arts and in the city of Paris. By the 1920s Paris was wholly identified with classicism in all aspects of social life. Theatre, cinema, and fashion thrived. Cafés provided open-air meeting places on every corner where passersby could see each other and be seen in turn.[11] Parisian urbanism, as mise-en-scène, became a potent model for cities around the world. However, the rise of a modern sensibility out of the same urban scene presents a conundrum. At the same moment that architects and urban planners around the world were looking to Paris as a model of fashion and order, the most progressive and vocal architect in Paris, Le Corbusier, condemned the streets as dank corridors that denied the city's population adequate air, light, and greenery. He famously proposed tearing down a section of Paris to erect apartment towers in a park, a graphic demonstration of a theory of urbanism that has since become a defining element of modern architecture's legacy. How could Paris be perceived as so culturally urbane and yet so oppressive at the same time?

The debate among architects concerned the proper role of architecture in staging urban life. The strategy for classical design as it developed in the École des Beaux Arts in Paris, paralleled traditional Italian theatre

DOI: 10.1057/9781137368683

and depended on architectural framing to create the familiar drama of watching and being watched. Views through windows and doors offered composed scenes that revealed people to each other. The emerging modern architecture, on the other hand, allied itself with cinema. Modern buildings created places, such as high-rise apartments where residents look out on a landscape but remain largely unseen, in a position of privilege that is no longer social or reciprocal. The buildings cast viewers as voyeurs.[12]

The duel carried on between Corbusian modernists and proponents of École des Beaux Arts classicism has dominated the historiography of the Paris in the 1920s, and of early modern urbanism generally. Yet the simple duality of polarizing arguments has obscured other trends and more subtle contributions by less strident architects and artists who embraced modern life and explored new, modern forms of seeing and being seen.

In fact, a third group of architects including Autant, Perret, and Mallet-Stevens charted another path altogether by drawing on the innovations of modern theatre directors. They looked to the work of Vslevolod Meyerhold in Moscow and Jacques Copeau in Paris, who produced modern performances that were neither framed like classical drama nor disembodied like cinema.[13] Meyerhold, Copeau, and other progressive directors who heard Craig's call, built architectural sets that actors engaged in expressive, physical movement, which spectators could feel as well as see. They experimented with innovative performance spaces that emphasized the actors' presence and played across the boundary of illusion, so spectators remained conscious of their role in the event, never falling completely into a story.

Autant and Lara's work is perhaps the clearest statement of the architecture of this third path. Their experiments in theatre proposed new scenarios that speak clearly of the performances integral to social events and to the design of social spaces in the city. They designed spaces and performances that depended on the creative power of spectators to construct experience out of multiple simultaneous elements that they saw, heard, or remembered. They emphasized the reciprocity of seeing and being seen and celebrated moments when the visual frame was crossed like a threshold. In performances and in design, they told mythic stories, which envisioned how people and architecture might act in a modern, collective society. "Life, this permanent theater" wrote Autant in 1925.[14]

DOI: 10.1057/9781137368683

Five theatres

With the actors of Art et action, Autant and Lara developed five distinct genres of modern performance that paralleled types of social events in the city. They presented several performances in each genre, sometimes adapting existing plays and sometimes writing new works for the theatric type. Each genre centered on a specific form of acting and required spectators to take a distinct role as those who watch. For each genre Autant sketched a theatre building that would position actors and spectators in very specific ways so that they would see each other and be seen in accordance with the nature of the event. Each of the five genres was unique, and all developed artistic principles of simultaneity and projected the roles and actions of an artistic, collective society.

The five genres, Choral Theatre (Théâtre choréique), Theatre of Space (Théâtre de l'espace), Theatre of the Book (Théâtre du livre), Chamber Theatre (Théâtre de chambre), and University Theatre (Théâtre universitaire), can be read as commentary on characteristic social events of Paris: spiritual communion, public festival, exhibition, mass media transmission, and civic debate, respectively. The five types of performance can also be read as proposals for how social events should be reconfigured in both form and meaning to support the new society that Autant and Lara envisioned.

Each chapter of this book considers one of the five types of theatre. Each presents an analysis of the spatial experience of performances, as they would have been experienced in their respective theatres, even though most of the theatres were never built. Analyses, including digital models of the five theatre buildings, show how each theatric type and its theatre reinterpreted the characteristic institutions of Paris and reconfigured them for a new society. Each chapter then traces the spatial ideas that Autant and Lara developed in theatre and shows how they emerged in the parallel work of their architect colleagues, principally Auguste Perret.

Autant's architectural designs for the five theatres make sense only in performance and the performances make sense only in their respective spaces. The event is the only measure. The analyses presented in this book focus on the actions of architecture with and among people, not on form, composition, or symbolic meaning. Each of Autant's designs for the five theatres is described as it would have been experienced by

DOI: 10.1057/9781137368683

spectators in the performance event—what they would see and hear, and how they would be seen by others.

In the early 1930s, Autant and Lara published limited runs of booklets that presented each of the five genres of theatre. Each booklet included manuscript plays in the genre together with Autant's sketches for the theatre building and an introduction explaining the type. In the 1950s they gathered the evidence of Art et action's work into an archive for the Bibliothéque Nationale de France.[15] They also collected the booklets into a single volume and published it in 1952 under the title, *Cinq conceptions de structures dramatiques modernes* (*Five Conceptions of Modern Dramatic Structure*).[16] In this rare volume they present the five types of theatre in relation to one another as a system that set up poles of dramatic experience to map a field of modern performance. The system, playfully referred to as a "quintology," presents a coherent theoretical statement that binds drama to architecture. The theatres demonstrate how buildings could act in the multiple dramas of modern urban life. Together they can be read as a poetic picture of the design and performance of the architecture of a modern town in a collective society.

Art et action in Paris between the Wars

Edouard Autant and Louise Lara took a circuitous path in arriving at their life's work together. Their personal histories, professional training, and immersion in the social and artistic life of Paris all contributed to the creation of the five theatres. Early in their experiments, Autant and Lara were tagged by the younger actors in Art et action as Père Système et Dame Abelle (Father System and Lady Bee). Autant's penchant for order defined his creative work as architect and director, culminating in the quintology. Lara deeply embraced the craft of acting and developed a rigorous training program for the troupe based in physical exercise and improvisation.[17] The motto of Art et action intimates the highly principled yet bittersweet quality of their quest: "Better to take a step forward and retreat with dignity than be successful and remain stationary."[18]

As a young man, Edouard followed in his father Alexandre Autant's footsteps. He pursued architecture, attending the École des Beaux Arts, where he received a classical education and training in the tradition of architectural proportion, propriety, and *mise-en-scène*. Autant built at

DOI: 10.1057/9781137368683

least three buildings: a casino in Enghein in 1900, an apartment house with elaborate glazed terracotta ornament in Paris in 1901, which he designed in association with his father, and his own house on Rue Emile-Menier in 1915.[19] Autant seems never to have established an independent professional office. His prospects may have been dampened by some of his extreme political views. He roundly rejected the authority of the Catholic Church (although he embraced Christian spirituality). He was a fervent Dreyfusard and a pacifist, and he entertained a short-lived and somewhat contradictory interest in anarchy.[20]

Autant married Louise Lara, and their son, Claude Autant-Lara, was born in 1901.[21] Lady Bee performed lead roles in the venerable state theatre, La Comédie Française, where she received some acclaim. Her politics also seem to have interfered with her professional career, for she was such a vocal pacifist during World War I that she had to take refuge in London for a few years with her teen-aged son and presumably her husband. It was at this juncture that they encountered the work of Edward Gordon Craig, which impressed them deeply.[22] When the family returned to Paris in 1917, Lara banded together with a group of artists, musicians, and poets surrounding Guillaume Apollinaire to form Art et liberté, a casual group that performed pan-arts pieces based on ideas of the simultaneity of modern experience. They met regularly at the house of architect Auguste Perret, who knew Autant from the École. Autant himself joined the group shortly thereafter and moved the venue to the Autant-Lara residence. Apollinaire died in 1918, and the group dissolved.[23] Autant and Lara founded Art et action in 1919 and continued to work with others from Art et liberté, such as the poet Henri-Martin Barzun and the composer Arthur Honegger.[24] Art et action presented performances for more than twelve years in a small loft they called the Grenier Jaune (Yellow Garret) located on the top floor of a building in Montmartre.

Autant and Lara's work in theatre ran parallel to Auguste Perret's work in architecture. Although they did not work together directly, Autant and Perret shared the classical values of their Beaux Arts education and the artistic philosophy of Art et liberté, as well as a commitment to the political left. Perret established a large, influential architectural practice and was well respected in Paris. He is still counted as a significant figure in histories of modern architecture, known primarily for his innovations in concrete construction and his debates with Le Corbusier. He is less recognized for his considerable contributions to public space, which

DOI: 10.1057/9781137368683

continue to enhance the quality of urban life in Paris today. For example, he was a strong voice behind replacing the Trocadero palace with a public plaza between two museums to open a view of the Eiffel Tower, a space that continues to take visitors' breath away.[25] His prodigious built work, including churches, museums, apartment buildings, government buildings, and theatres shares many of the principles that Autant and Lara demonstrated in performance. Perret also shared a sense of the mythic role of architecture, a sentiment, most clearly seen in his sensitive contribution to the theory of architecture written late in his life.[26]

Early in Autant's career, while still practicing architecture, he wrote plays that specify the role of the building trades in a larger symbolic system. The first, *Ceremonie de la parabole des corporations* (*Ceremony of the Parable of the Guilds*), of 1913, celebrated the arts of construction as symbolic links to the spiritual order of the natural world, a sentiment consistent with nineteenth-century symbolist poetry.[27] In the play, each of the building crafts has a specific role in maintaining the proper place of humanity in the cosmos. The mason leads as an artist-priest who works the stones of the earth to raise chimneys and spires as offerings of earth to heaven. The carpenter follows, rendering the form of the living tree into structures that define the bodies of buildings. The beams are roofed in copper, like leaves that cover the limbs of the oak or olive. The painter then decorates structure as fruit decorates a tree. At the end of the play, each tradesman bends to the task of constructing the human body:

> And the mason shapes the flesh
> And the carpenter carves the bones
> And the roofer spreads out the skin
> And the joiner separates the cartilage
> And the metal worker brings together the muscles
> And the stove-maker warms the heart[28]

This quasi-classical set of correspondences between the living earth, the arts, the body, and the cosmos give work—specifically the work of building construction—a heroic purpose, which requires selfless dedication and spiritual purity. The high calling of architecture places it at the center of the arts, a theme that reappears several times in Autant's writing, including a cycle of plays for performance in the Theatre of Space of 1937.

All of Autant and Lara's endeavors were grounded in the city of Paris, including Autant's education and professional work as an architect and

DOI: 10.1057/9781137368683

their work together in theatre. Their home was in the 16th arrondissement, a district newly built on the model established by Baron von Haussmann, which controlled the layout of streets of various sizes and the location of amenities, such as cafés, parks, metro stations, and public buildings. The architectural logic of proportion and propriety, which Autant studied at the École des Beaux Arts, extended Haussmann's plan into the design of buildings, imposing strict standards for style and detail. The entire urban scheme was executed impeccably in Autant and Lara's neighborhood, from the vertical proportions of windows overlooking the street to the distance between metro stations.

The orderly architectural system supported an urban culture of seeing and being seen that was closely linked with theatre. Buildings framed and presented people elegantly, and the Parisian bourgeoisie dressed for the part. Along commercial boulevards, shop windows offered a phantasmagoria of fashion in theatrical tableaux, each a small drama for passersby. In the 1920s the "décor of the street" was the subject of city-sponsored competitions for building façades designed to enliven the scene. Photographs of the winning entries appeared in a series of publications from 1925 to 1931 with accompanying essays on the history and significance of shop décor written by Robert Mallet-Stevens and René Herbst, younger architects acquainted with Autant and Lara's artistic circle.[29] In 1925, the French government hosted the hugely successful Exposition des Arts Decoratifs, which transformed Paris into a veritable theme park of sophisticated urban living for an international audience and confirmed that it was *a*—if not *the*—center of fashion, urbanism, and luxury in the world.[30]

Within this commercial milieu, Autant and Lara established Art et action as a pointedly non-profit, "experimental" theatre, as opposed to an "avant-garde" theatre, which might have been taken to mean "stylish." They distained most theatre as passive entertainment and sought to actively engage sympathetic audiences in performances that commented upon the contemporary human condition at a symbolic or mythic level. Modern theatre, they held, should act in the real world, beyond the confines of the stage. More specifically, Autant and Lara based Art et action on a Soviet artistic collective.[31] The plays they adapted and wrote, the forms of theatre they developed, and their activities off-stage advocated radical artistic freedom in a collective society.[32] In Paris, they shared these convictions with many artists and literati, yet they made a more extreme and personal commitment than most.

DOI: 10.1057/9781137368683

Autant and Lara followed developments in the nascent Soviet Union, where theatre and architecture took on crucial roles in ideological education. Theatre became a means to transform passive spectators into active Soviet citizens by instructing and inspiring them to assume new roles in collective communities. Architecture was tasked with shaping the city both spatially and symbolically to place people in relation to one another so they could act effectively in these new roles. In the early years after the 1917 Russian Revolution, progressive theatre directors and architects innovated freely to reinvent their arts to serve a Communist society. In Moscow, celebrations such as May Day parades were staged in Gorky Street, which enveloped vast crowds in a demonstration of Soviet solidarity.[33] Agit-prop theatre groups performed in small towns throughout the countryside to teach the new way of life. In cities, new worker's clubs defined the spaces for leisure activities, always centered on a theatre.[34] Theatrical forms such as literary readings, street theatre, and children's puppet theatre were adapted to mold and educate the population.

Autant and Lara sought out these new forms of theatre on a visit to Moscow in 1928.[35] They specifically followed the work of Russian constructivist theatre director Vsevolod Meyerhold, who had brought performances to Paris and enjoyed broad international influence in the 1920s.[36] Meyerhold's performances cast both actors and audience in roles that modeled a new society in which daily work was heroic and meaningful. He wrote, "We have a new public which will stand no nonsense— each spectator represents, as it were, Soviet Russia in microcosm."[37] Meyerhold worked with designers such as Luibov Popova to develop three-dimensional architectural sets that the actors climbed over and through.[38] He trained actors with a series of "biomechanical" exercises to achieve an expressive form of motion akin to dance.

The artistic ideas underlying Constructivist set design and dramatic techniques built on Edward Gordon Craig's innovations in modern theatre prior to World War I, which had an artistic rather than political genesis.[39] At the turn of the twentieth century, well before the Russian revolution, Craig, in concert with Symbolist dramatists such as Maurice Maeterlinck in Germany and Aurélien-Marie Lugné-Poe in France, conceived performances as transformative ritual or myth and sought inspiration in Greek drama, medieval carnival, "primitive" rites of passage, and Dionysian festival.[40] They shared the conviction that drama should draw back the curtain of ordinary life so audiences might glimpse archetypal Man within an orderly cosmos. Choosing classical stories of

DOI: 10.1057/9781137368683

cosmological structure or mythic allegories, they seized on Athenian dramatic forms to recreate theatre as a sacred realm and performances as modern-day oracles. Images dwelt as symbols, inviting spectators to slowly and rhythmically enter layer upon layer of meaning.

Craig explicitly made the leap between this poetic symbolist drama and architecture. Starting in 1908, he published *The Mask*, a journal largely of his own articles, dedicated to remaking theatre through the design of sets and performance spaces. Craig sought a return to the origins of theatre, where he envisioned mythic stories played out in the real city among its buildings. He deplored the illusion of painted scenery and the Italian tradition of the proscenium arch, arguing that modern performances should help reconstruct the ancient connection between theatre and the real world. He observed that the essential qualities of the theatre—characters, setting, music, and words—should return to the city and to nature. Greek dramas, he wrote, "played in the daytime and with the sun streaming upon the actors and audience alike.... It was the movement of the sun upon the architecture which moved the audience."[41] He continued, arguing that actors and elements of the set, each one strong and independent, should interact with one another to develop the tensions of the drama. Sets should not depict fictional scenes: rather, they should construct real spaces that actors could occupy physically so that they could express the story through position and movement. Instead of classical backdrops governed by single point perspective, Craig offered raised platforms, steps, walls, and openings that actors inhabited without illusion and that the audience could see from many angles. The entire width, depth, and height of the stage were available for action. Actors moved in the same space as spectators, even crossing into the aisles of the theatre. Craig's spatial innovations redefined theatre, influencing a generation of directors across Europe.

Parisian artists such as Autant and Lara who received Craig's call found it compatible with a developing poetic idea of simultaneity—that a work of art should be considered spatially rather than sequentially, thus redefining the narrative arts of performance as arts of space, akin to architecture. In 1913 Guillaume Apollinaire wrote that Cubist paintings represented complete objects, incorporating "all facets of the geometric surface" simultaneously in the space of the canvas.[42] The poet described the broad ideas of modern, simultaneous experience shared by the artists of Art et liberté as well as many associated with Cubism, Futurism, and Orphism. Apollinaire also participated in a much more specific

DOI: 10.1057/9781137368683

movement in art dubbed "Simultaneisme," a name that was almost immediately appropriated to describe a doctrine of poetry.[43] Though the movement was short-lived, the larger ideas that Apollinaire and others developed were broadly influential.

Apollinaire referred to the work of French philosopher Henri Bergson, who proposed that sensory perception integrates subject and object into events with a thickness in time, or "duration," that cannot be subdivided. Bergson challenged the Aristotelian definition of time as a series of infinitely divisible instants to argue that events are perceived whole, as if simultaneously.[44] He valued intuition as highly as intellect, writing that intuition integrates sensual information with imagination, memory, and often language to create experiences that are remembered complete. While intellect can divide and categorize experience, intuition assembles and creates it. Experience is actively created in the intuitive imagination of the viewer from multiple impressions, both sensory and imaginary.

Apollinaire joined some of Bergson's ideas with Cubist imagery to posit that poetry could be visual, simultaneous, and somehow spatial.[45] He wrote "simultaneous" poems, which contain complex internal rhythms, rhymes, images, and symbols that link words to each other thickly, creating a dense experience of sound and meaning in a structure that he considered both orchestral and architectural. To accompany several of Apollinaire's poems composer Arthur Honegger wrote music that was almost figurative, adding expressive sound to poetic imagery and lifting poetry into multi-layered performance.

During and just after the close of World War I, Art et liberté pointedly reached across the arts to bring together poets, painters, musicians, actors, and architects.[46] In addition to Autant, Lara, and Perret, the group included Amadée Ozonfant, who later developed a "purist" style of painting with Le Corbusier; Albert Gleizes, one of the principal theorists of modern art; the composer Honegger; and young poets including Henri-Martin Barzun.[47] Barzun, who later wrote several pieces for Art et action, argued that simultaneous, spatial poetry was the voice of the modern age.[48] He held that a poem's significance lies in the correspondences between the separate voices that reflect the "essential unity of life in its diverse manifestations." He emphasized poetry's cross-sensual nature, writing that poetry must be experienced bodily, "it must have volume, mass and depth."[49]

Barzun concluded that in order to perform modern, simultaneous poetry fully, a theatre should be designed specifically for the art form, as

DOI: 10.1057/9781137368683

a concert hall is designed for music and a gallery for art.[50] He described a theatre for poetry that would be light, bare, and lit by the sun from above. "The afternoon sunlight will put all works to the test, no matter the genre." Poetic theatre should have no scenery, costumes, or decorative detail. The performance should not be divided by traditional acts, but be ordered according to new periods appropriate to the piece. And it should "kill successive language, academic declamation, theatrical tirade, and all the dusty conventions of the popular stage." Such a theatre would serve poetry and poetry alone. It would appeal to "listeners more than viewers, and to the soul more than the eye." Listeners and performers would participate in "subjective collaboration" and poetic experimentation. He concluded that "Perhaps some grand idea, some genial reform, which would be able to contribute to all of art, could move out from this studio, from this laboratory, since poets, like savants, inventors and philosophers, pursue the same goal—knowledge."

Autant and Lara's five genres of performance evolved from the core ideas of simultaneous poetry and can be considered collectively as types of poetic experience. Each of Autant's proposals for theatre buildings has elements envisioned by Barzun. Some are lit solely by the sun, some eschew scenery and costumes (while others embrace them), some emphasize sound over view, and all share the fundamental characteristics of simultaneous performance, engaging the audience directly in multiple elements juxtaposed with one another. The five theatres mirror Auguste Perret's broad definition of architecture as construction that "fulfills the fleeting with the permanent," with a Bergsonian coda specifying that the imagination creates permanent memories from a confluence of fleeting impressions.[51] Their five forms of dramatic structure explore, in form and in action, the role of architecture in making human drama.

Art et action's contribution

In 1936 the Socialist Popular Front came to power in France just long enough to sponsor an international exhibition of arts and technology that demonstrated in design some of the values of a free, artistic and collective society.[52] Both Perret and Mallet-Stevens designed buildings and public spaces for the fair, and Autant and Lara seized the opportunity to build one of their five theatres—the Theatre of Space.

DOI: 10.1057/9781137368683

Following this golden moment in the eye of an international public, the artists affiliated with Art et action found themselves swimming against the tide of global politics. The Popular Front lost power in 1937, the same year as the fair. By the outbreak of World War II, Autant and Lara's ambitious project had succumbed to the crushing effects of economic depression and political trauma. During and after the war, the militancy of nationalism and Joseph Stalin's ruthless rule in the Soviet Union hardened discourse in Europe and fueled the repression of any ideas that smacked of Communism. The shift in political climate affected the tone of the arts as well as the demeanor of social life for many years. Although Perret's firm reemerged in the postwar period to rebuild French cities, the work of Autant and Lara fell deep into obscurity.

The Cold War brought long-term changes in attitudes, which remade urban life in a Modernist model.[53] Western architects eschewed any feature that could be construed as overtly theatrical, hewing to a stand-offish urbanism that offered views outward from private dwellings to a landscape or distant horizon rather than views inward toward each other in the city. Architects adopted cinema rather than live theatre as a model for architectural experience, defining an inhabitant as spectator in an almost virtual position, where he (always a man) could see out into a landscape without being seen, as if behind a moving camera.[54] The deep association that theatre and architecture had long enjoyed was gone, notwithstanding momentary revivals.

In the 1970s and '80s, architects associated with the postmodern movement in architecture rediscovered set design. Charles Moore and others built playful urban spaces explicitly as stage sets.[55] Other architects and urban designers revived classical colonnaded buildings and returned to principles of nineteenth-century American town planning, advocating a New Urbanism of walkable, tree-lined boulevards, town greens, and stately building façades. Yet while both groups mimicked historic forms (either in earnest or with tongue in cheek), their work remained detached from the deeper tradition of architectural mise-en-scène.

In recent years leading architects have once again embraced urban life as a priority toward building vibrant and sustainable cities, and with it the implicit link between theatre and the city. Architects such as Rem Koolhaas, Bernard Tschumi, and Coop Himmelblau began in the 1970s not to revive old forms but to innovate, explicitly investigating the role of architecture in social events.[56] Today, their work joins that of other

DOI: 10.1057/9781137368683

architects, including notably Diller & Scofidio who develop architecture in parallel with performance pieces.

Autant and Lara's work offers contemporary architects a crucial, modern interpretation of the rich tradition of architectural thought that links theatre with the city. They demonstrate an approach to design centered on action rather than form as well as a means in theatre to experiment creatively with spatial situations. Each of the five theatres offers one path into design, as if to scout a territory for future investigation.

Notes

1 Michel Corvin (1976) *Le Théâtre de recherche entre les deux guerres: Le laboratoire Art et Action* (Théâtre années vingt; Paris: La Cité-L'Age d'Homme) p. 150.

2 Eduard Autant (1872–1964) Parisian architect turned theatre director, principal of Art et action; Louise Lara (1876–1952) Parisian actor and dancer, principal of Art et action.

3 Art et Action, "Théâtre du chambre" in Art et action (1952) *Cinq conceptions de structures dramatiques modernes*, 13 parts in one volume (Paris: Corti) p. 14.

4 Guillaume Apollinaire (1880–1918) Influential French poet, critic, playwright, born in Italy.

5 Auguste Perret (1974–1954) French architect who pioneered reinforced concrete construction with his brother Gustave Perret. Robert Mallet-Stevens (1886–1945) French architect and set designer for cinema.

6 Autant was a first-year student in 1894 and received his diploma in 1900. Perret was first-year student in 1893 but did not graduate. See David de Penanrun and E. Delaire (1907) *Architect élèves de l'Ecole des beaux arts, 1793–1907* (Paris: Libraire de la Construction Moderne) pp. 165 & 370.

7 Le Corbusier (psued. of Charles-Édouard Jeanneret, 1887–1965) The most influential French architect of the 20th century.

8 Frances A. Yates (1969) *Theatre of the World* (NY: Barnes & Noble University of Chicago Press) pp. 169–73.

9 For a study of the urban origins of theatrical forms see David Wiles (2003) *A Short History of Western Performance Space* (Cambridge, UK: Cambridge University Press).

10 Sebastiano Serlio (1996) *On Architecture* (New Haven: Yale University Press, 1996), Book II "On Perspective." This book was first published in Italy in 1545.

11 Much has been written about the urban life of Paris in the 1920s; for a vivid history of the role of fashion in urban life see Tag Gronberg (1998) *Designs on Modernity* (Manchester: University of Manchester).

DOI: 10.1057/9781137368683

12 Beatriz Colomina (1994) *Privacy and Publicity* (Cambridge: MIT Press) p. 90.

13 Vsevelod Meyerhold (1974–1940) Russian Constructivist theatre director pioneered biomechanics; Jacques Copeau (1879–1949) Director of Théâtre du Vieux Colombier in Paris.

14 Edouard Autant and Louise Lara (1925) *La Philosophie du théâtre*, Fonds Art et Action (Paris) p. 9.

15 The Art et action archive resides in the Collection des Arts du Spectacle, Bibliothéque Nationale de France.

16 Art et action, *Cinq conceptions de structures dramatiques modernes*. This book assembles many of Art et action's previous publications. The press run was extremely small. One copy is held by the Library of Congress. Autant, Lara, and Lara's niece, known as Akakia Viala, assembled an archive of Art et action's work including scrapbooks of photographs and letters, manuscripts of plays, and cardboard models of some of the five theatres.

17 Her training program is laid out in Art et action (1956 (1929)) "Cours de comédie spontanée moderne (1e, 2e et 3e année) technique et réalisations," in Art Et Action (ed.), *Cinq conceptions de structure dramatiques modernes* (Paris: Corti) and Art et action (1952 (1930)) "Cours de comédie spontanée moderne (4e année) Du syllogisme au dilemme," in Art et Action (ed.), *Cinq conceptions de structures dramatiques modernes* (Paris: Corti).

18 This slogan appears on all Art et action publications, playbills, and announcements.

19 The Casino d'Enghien was completed in 1900 and has been extensively modified. The apartment house at 14 rue d'Abbeville was completed in 1901 and is credited to both Edouard and his father Alexandre Autant. The glazed terracotta work was by Alexander Bigot. Autant and Lara's own house dates to 1915 and is located at 2 Rue Emile Menier, although the street numbering has changed. I couldn't be sure which house was theirs.

20 Corvin, *Le Théâtre de recherche entre les deux guerres: Le laboratoire Art et Action* p. 32. Autant had a falling out with his father over the Dreyfus Affair that set his course as a free thinker. See Discours de M. Francis Girod prononcé lors de sa réception sous la Coupole en hommage à Claude Autant-Lara [archive], 17 décembre 2003, available at http://www.academie-des-beaux-arts.fr/actualites/receptions/2003/girod/discours%20girod.htm.

21 Claude Autant-Lara (1901–2000) assisted in a number of Art et action performances as a costume and set designer. He became a cinema director of some note with films such as *Fric-Frac* (1939), *The Seven Deadly Sins* (1952), *Le rouge et le noir* (1954), and *Le Comte de Monte-Cristo* (1961), but he never succeeded as he had hoped and faded from popular view in the 1960s. At the age of 88, he was elected to the European Parliament to represent the National Front, where he made himself instantly unwelcome in hateful speeches in which he denied the Holocaust and

DOI: 10.1057/9781137368683

lashed out at racial minorities. His memoir, *The Rage in the Heart*, was published in 1984.

22 When Lara returned to Paris and briefly returned to *La Comédie Francaise*, she requested that Craig design sets for a piece that was to have been her swansong. She had proposed Paul Claudel's Tête d'Or (Golden Head) with modernist director Jacques Copeau. Claudel refused. See Corvin, *Le Théâtre de recherche entre les deux guerres: Le laboratoire Art et Action* p. 125.

23 Apollinaire died in November of 1918 of Spanish Influenza.

24 Henri-Martin Barzun (1881–1973) French poet and founder of Simultaneiste movement in poetry; Arthur Honegger (1892–1955) Swiss composer who lived in Paris known for innovative music the makes reference to real-world sounds.

25 Other architects designed the plaza, but Perret spoke forcefully in support of the project. See Auguste Perret et al. (2006) *Anthologie des écrits, conferences et entretiens* (Paris: Editions Le Moniteur) p. 239.

26 Auguste Perret (1952) *Contribution a une theorie de l'architecture* (Paris).

27 Autant's closest connection to Symbolist ideas was through poet Fernand Divoire (a member of Art et liberté), who continued to work with Art et action.

28 See Edouard Autant (1915) *Paraboles des Corporations* (Stock & Co) p. 31.

> Et le maçon pétrira la chair,
> Et le charpentier taillera les os,
> Et le couvreur étendra la peau
> Et le menuisier détaillera les cartilages,
> Et le serrurier articulera les muscles,
> Et le fumiste échauffera le coeur

29 Rene Herbst (1891–1982) Parisian designer of interiors and furniture. See Rene Herbst and Robert Mallet-Stevens (1929) *Présentation, 2e série: Le Décor de la rue, les magasins, les étalages, les stands d'exposition, les éclairages* (Paris: Les Editions de "Parade"). Herbst's publications on shop facades include Rene Herbst (1925) *Devantures et Installations de Magasins* (Paris: Moreau), Rene Herbst (1929c) "L'étalage," *L'Encyclopédie des arts décoratifs* (Paris), Rene Herbst (1929b) *Modern French Shopfronts* (London), Rene Herbst (1929a) *Boutiques et magasins*, ed. Charles Moreau (Paris: C. Moreau). Also: Rene Herbst (1931) *Nouvelles devantures et Magasins; agencements de parisiens*, ed. Charles Moreau (Editions d'Art; Paris: C. Moreau).

30 See Gronberg, *Designs on Modernity* p. 3.

31 François Jourdain described Art et action as an "embryo of a better society" and he quotes the Communist Manifesto, "the free development of each will be the condition of the free development of all." See Francis Jourdain (1954) "Preface," in Akakia-Viala (ed.), *Art et action, laboratoire de théâtre. Catalogue de la collection donnée à la Bibliothèque de l'Arsenal* (Paris: Bibliothéque Nationale de France).

DOI: 10.1057/9781137368683

32 For example, they staged "Liluli," a play critical of both war and religion. Romain Roland (1920) *Liluli* (London: Boni & Liveright). Corvin describes their politics as tending toward anarchism in relation to the church and toward Socialism on issues of social structure. Above all, they insisted on creative freedom. Autant criticized copyright law, arguing that it was a pernicious extension of private property into art, which should be free to all. Autant and Lara, *La Philosophie du théâtre*, p. 7.

33 Greg Castillo (1994) "Gorky Street and the Design of the Stalin Revolution," in Zeynep Çelik, Diane Favro, and Richard Ingersoll (eds), *Streets: Critical Perspectives on Public Space* (Berkeley, CA: University of California Press) pp. 57–70.

34 For example, Konstantin Melnikov's Rusakov Workers' Club for employees of the Moscow Communal Economy (1927–29), which centered on three theatres that projected out over the street. See Catherine Cooke (1995) *Russian Avant-Garde: Theories of Art, Architecture and the City* (London: Academy Editions) p. 61.

35 Autant and Lara traveled to Moscow with François Jourdain and Luc Durtain. See Corvin, p. 44. Lara wrote a book on their experience of Russian theatre. See Louise Lara (1928) *L'Art dramatique russe in 1928* (Paris: Bergerac; imprimerie de la Lemeuse).

36 Meyerhold presented plays at the 1925 Paris International Exhibition of Decorative Arts. Tairov presented several plays at the Théâtre des Champs Élysées in 1923. In 1928, François Jourdain organized a banquet to honor. See Corvin, p. 44. After Stalin took power in 1932, constructivist drama and modern art in general were rejected by the state.

37 Meyerhold, "On the Staging of Verhaeren's The Dawn" (1918) in Vsevolod Meyerhold (1969) *Meyerhold on Theatre*, trans. E. Braun (NY: Hill & Wang) p. 170.

38 Luibov Popova (1889–1924) Russian avant-garde artist. Nancy Van Norman Baer (1991) *Theater in Revolution: Russian Avant-garde Stage Design 1913–1935* (San Francisco: The Fine Arts Museums of San Francisco, Thames & Hudson) p. 65. Popova designed a well known set for Fernand Crommelynk's *The Maganminous Cuckold*, which was staged in Moscow in 1922 and Paris in 1930.

39 Craig wrote extensively and produced wood cut prints that were exhibited throughout Europe. He founded the journal *The Mask* in 1908 as a voice for modernizing theatre. His publications include Edward Gordon Craig (1913) *Towards a New Theatre: Forty Designs for Stage Scenes* (London, Toronto: J. M. Dent & sons), Edward Gordon Craig (1921) *The Theatre – Advancing* (London: Constable). Edward Gordon Craig (1925) *Books and Theatres* (London: J M Dent & Sons). Edward Gordon Craig (1960 (1911)) *On the Art of the Theatre* (New York: Theatre Arts Books).

DOI: 10.1057/9781137368683

40 Maurice Maeterlinck (1862–1949) Belgian playwright, poet and essayist. Aurélien-François Lugne-Poe (1869–1940) actor, theatre director and scenic designer in Paris. Christopher Innes (1993) *Avant Garde Theatre 1892–1992* (London: Routledge) p. 19.

41 Innes, *Avant Garde Theatre 1892–1992* p. 59.

42 Guillaume Apollinaire (1972) "Modern Painting," in Leroy C. Breunig (ed.), *Apollinaire on Art: Essays and Reviews 1902–1918* (NY: Viking Press) p. 269.

43 The ideas of simultaneity in modern experience were broad and deep; they became integrated into modern abstraction at many levels. Apollinaire described Cubism as a simultaneous representation of an object. "Simultaneisme" describes a short-lived movement in art allied with Italian Futurism that emerged in 1913 and centered on Guillaume Apollinaire, Robert and Sonia Delaunay, and poet Blaise Cendrars. In the same year, poet Henri-Martin Barzun, a younger member of Art et liberté, used the term to describe his own literary doctrine. There was some disagreement on who had rights to the name. For an original source see Guillaume Apollinaire (1914) "Simultanisme-Librettisme," *Les Soirées de Paris*, 25 (June 15, 1914). For a review of the Simultaneiste movement, see Matthew Affron (2013) "Contrasts of Colors, Contrasts of Words," in Leah Dickerman (ed.), *Inventing Abstraction 1910–1925* (Museum of Modern Art), 82–93, p. 82.

44 Henri Bergson (1859–1941) Influential French philosopher who developed ideas of duration and intuition. Bergson lays out the entire argument supporting perceptual "duration" in Henri Bergson (1946) *The Creative Mind*, trans. Mabelle Andison (NY: Philosophical Library) pp. 14–25.

45 Adrian Hicken (2002) *Apollinaire, Cubism and Orphism* (London: Ashgate) p. 9. Apollinaire described orphic poetry as a modern form, referring to the myth of Orpheus who charmed the gods with his poetic song and was granted permission to enter Hades to retrieve his lover, Eurydice. When he turned back to see whether she was following, she was lost.

46 See Corvin, *Le Théâtre de recherche entre les deux guerres: Le laboratoire Art et Action* p. 67. Apollinaire had been a central figure in the arts before WWI, writing extensively and bringing diverse artists together. He fought in WWI, was injured, and subsequently died of his injuries.

47 Amadée Ozenfant (1886–1966) Painter who worked with Le Corbusier to develop Purist style of painting. Albert Gleizes (1881–1953) French artist and theoretician who was a founder of Cubism.

48 Art et liberté, the precursor of Art et action performed Barzun's "La montaigne" (The Mountain) in 1917. Art et action performed Barzun's "Panharmonie Orphique" (Orphic Panharmony) in 1922, "L'Universale" in 1923, and "Hymne des forces" (Hymn to Power) in 1926. Art et action also performed works by poets closely associated with Barzun: Sébastien

DOI: 10.1057/9781137368683

Voirol and Fernand Divoire as well as explicitly following Barzun's ideas of simultaneity in the performance of classical works such as Jean d'Arc by Peguy. See Corvin, *Le Théâtre de recherche entre les deux guerres: Le laboratoire Art et Action* p. 40.

49 Henri-Martin Barzun (1912) *L'Ere du drame* (Paris: Figuiere & Cie.) p. 34.

50 Barzun, *L'Ere du drame* p. 124. All quotes in this paragraph are from the same source.

51 *"Architecte est le constructeur qui satisfait au passager par le permanent."* One of the first aphorisms in Perret, *Contribution a une theorie de l'architecture*. Reprinted in Britton pp. 230–237. Quote on p. 232.

52 *Le Exposition Internationale des Arts et Techniques dans la Vie Moderne* took place on the Champs de Mars at the foot of the Eiffel Tower in 1937.

53 See Greg Castillo (2001) "Socialist Realism and Built Nationalism in the Cold War "Battle of the Styles,"" *Centropa*, 1/2, 84–93.

54 See Colomina, *Privacy and Publicity*. The viewer is archetypically male.

55 Charles Moore (1925–1993) American architect, educator and theoretician. Moore's 1978 Piazza de l'Italia in New Orleans is a signature project of urban set design.

56 See Bernard Tschumi and Irene Chung (eds) (2003) *The State of Architecture at the Beginning of the 21st Century* (Columbia books of Architecture, NY: Monacelli Press).

DOI: 10.1057/9781137368683

1

Hearing the Voices of the Universe: Choral Theatre

Abstract: *Choral theatre performances of simultaneous poetry surrounded audiences with atmospheric music, voice, light, and dance to create a modern spiritual experience that reinvented the ancient Greek chorus, using Futurist ideas of polyvocal simultaneity and synaesthesia or cross-sensory perception. Autant proposed an acoustic shell structure to reflect orchestral music into full resonance, while multiple choruses sang poetic verses as vocal figures suspended in the sound-laden air. Auguste Perret's 1928 concert hall, the Salle Cortot, similarly transforms the music "like a violin." Two of Perret's churches include hollow towers that resonate music in a deep hum, as if from the earth itself. In the artistic circle of Autant and Perret, this shared immersion in sound was considered a secular form of spiritual communion.*

Read, Gray. *Modern Architecture in Theatre: The Experiments of Art et Action.* New York: Palgrave Macmillan, 2014. DOI: 10.1057/9781137368683

DOI: 10.1057/9781137368683

In 1917 Art et liberté presented a choral poem "Le Sacre du printemps" (Rite of Spring) by Sébastien Voirol, which reinterpreted the iconic music of Igor Stravinsky written for a famous performance by the Russian Ballet four years earlier.[1] Art et liberté's performance included two choirs and several soloists, each chanting distinct parts that merged with and separated from one another in a complex pattern. A choir of men sang simultaneously with a choir of adolescents yet were spatially separated from them. A "300-year-old man" chanted parallel to a chorus of "elders who knew the rituals of the night," and a "pale young man sang with a young woman whose eyes were cast down."[2] An orchestra accompanied the singers and rendered some of the poetic themes musically, adding another layer to the composition. In addition, Louise Lara danced a ritual of struggle and release. The performance demonstrated the principles of artistic simultaneity by presenting multiple independent parts that intersected each other.[3] Between the sounds of spoken or chanted words, the instrumental music, and the dancer's gestures, spectators might perceive in their own minds sparks of poetic correspondence. At least, that was the artistic intention. Listeners of the actual performance, however, may have had a hard time distinguishing the words, because the simultaneous choral parts of the poem were performed on a single, central stage, so they were not separated spatially. The words probably muddled together, disrupting any sense. Newspaper reviews of similar choral pieces by Art et action readily denounced them as unintelligible cacophony.[4]

Yet Autant and Lara persisted. Autant wrote that composing words and music for three-dimensional space transformed poetry into a bodily experience of sound and sense that possessed the immediacy of real life.[5] In subsequent works, such as their 1929 presentation of Arthur Rimbaud's "Une Saison en l'enfer" (A Season in Hell) Autant and Lara conceived the performance architecturally. They placed the multiple performers around the audience, giving the voices specific locations.

Studies of auditory perception show that if listeners can locate a sound spatially, then they can focus attention on it and screen out other noises—a skill honed in cocktail party conversation. Spatially separating the voices makes it possible for listeners to focus attention on one voice among many or to shift attention from one voice to another at will. In Art et action's performances with spatially separated voices, listeners could cast attention from voice to voice and construct multiple meanings out of the simultaneous verses.

DOI: 10.1057/9781137368683

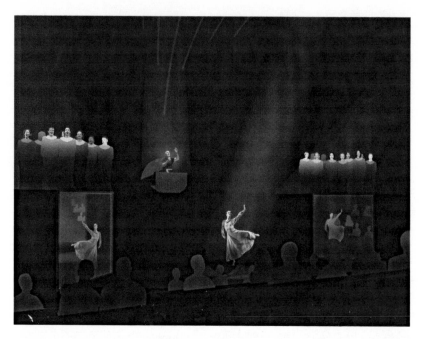

FIGURE 1.1 *Interior view of Choral Theatre (Théâtre Choreique) based on sketches by Edouard Autant (Damir Sinovcic and author)*

This spatial innovation in performance, Choral Theatre, was the first of Autant and Lara's five conceptions of dramatic structure and established the poetic core of their quintology of theatric form. In 1933 Autant sketched a building for Choral Theatre with an egg-shaped dome enclosing audience, choral singers, and orchestra in a single, resonant space (Figure 1.1). Although the theatre was never built, its unusual design suggests acoustic qualities that would give sonic depth to performances of simultaneous poetry, as composed by their artistic collaborators.

The acoustic design Autant sketched for the choral theatre building relates to that of a concert hall and two churches by Auguste Perret, which still stand. The interior volumes of these buildings reflect sound to create dense sonic atmospheres that surround listeners on all sides, as if they are suspended in music; each new phrase of the melody arriving as a crisp figure written in the air. Architecture and sound are integrated so fully that Perret's design makes sense only in

DOI: 10.1057/9781137368683

performance and the music for which the spaces are designed seems to come to life only there. This unity of building and sound recalls the stone vaults of medieval chapels, which measured to the resonant dimensions of monastic chant, building the voices spatially into bone-vibrating prayer.[6]

Autant explained the spiritual role of choral theatre: "What would be the human voice without the purpose of expressing the harmonious life of worlds at every height and at all sequences and extended in all directions, ideal waves of thought that join the waves of the universes; the horizon and the undulation of the sea and the wind, the pulsation of the ephemera of our blood and spirit?"[7] In this light, the spatial sound of Choral Theatre constructed by both Autant and Perret can be read as a proposal for a modern spiritual ritual in the city that celebrates a link between community and cosmos.

Art et action's description of Choral Theatre performances alluded to the ancient Greek chorus in both form and vocal quality. Autant and Lara had adopted Edward Gordon Craig's quest to reinterpret the Greek chorus for modern theatre, as a unifying voice in between audience and actors. Craig considered the chorus to be the primal element of ancient theatre, which created a spiritual space, or "choros," within the real space of the city to reflect the encompassing cosmos in song.[8] The collective voice and swaying movement of the chorus were human and present, opening a space of vision or *theatron* in the city. Craig likened the chorus to a natural phenomenon, like a flock of birds wheeling above Trafalgar square, "in their own god-like way." He continued, "It was the movement of the chorus that moved the onlookers ... time seemed actually to be in motion. The movement was felt, but felt through seeing."[9] Craig described the chorus as a human architecture that seemed to embody the city itself, singing the collective truths of the populace.

The poets in Art et liberté who continued to work with Art et action, invented modern simultaneous poetry as the complex voice of many individuals merged to sing a shared truth. The poet Fernand Divoire wrote, "Simultaneism is a way to sense the world in its unity of millions of voices—the ALL: voices, thoughts, noises, movements."[10] Poetry progressed from an individual voice to a collective song and then to a musical atmosphere, in order to construct a modern symbolic cosmology that unified the individual with the universe.

DOI: 10.1057/9781137368683

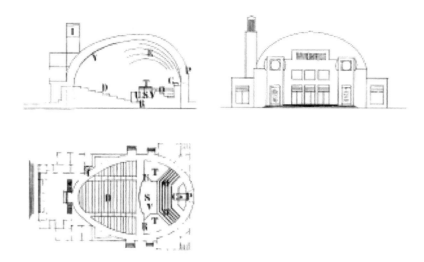

FIGURE 1.2 *Choral Theatre sketches by Edouard Autant (Courtesy: Corti Press)*

Note: Egg-shaped plan shows two raised platforms for choral singers (T), a central stage for dancers (S) with mirrors to reflect their movements (U), and an orchestra pit facing away from the audience, so the conductor faces toward the audience. Section shows the levels of performers and audience as well as heaters and chillers in domed ceiling. Key: Exhaust chimney for air movement (I); Platform for Orchestra Conductor (C); Tiered Orchestra Pit with moveable screen (O); Illuminated Stage (S); Choir (T); Soloist (V); Mirrors (U); Audience (D); Heating Units (E); Refrigeration Zone (Y); Exhaust Vents (R); Air Intake (P).

The Choral Theatre building in Performances of simultaneous poetry

Autant's sketches for a Choral Theatre building describe an architectural form that would have the acoustical effect of giving specific locations to voices and music, so that an audience would hear them arrayed spatially. Instrumental music would surround listeners as if coming from all directions at once, while each choral group would hold a specific position, allowing listeners to locate each and attend to each independently. The musical rhythms would become visible in the movement of dancers on a central stage.

Autant drew the form of the Choral Theatre as two intersecting parabolas in plan, describing walls that curve up into an egg-shaped dome. Performers fill the wide end while the audience sits in the narrow end. The curving double shell, presumably built of concrete outside

DOI: 10.1057/9781137368683

and plaster within, offers an acoustically reflective surface, which would gather and project the music of the orchestra toward the audience. The orchestra faces away from the audience and plays toward the curved wall of the shell, while the conductor stands on a high platform on the central, longitudinal axis, facing both the musicians and the audience (Figure 1.2, "O" and "C"). From this position, he sets the rhythm of the perform-ance both visually and sonically with his baton. Flanking the orchestra, two platforms elevate choral singers almost to the level of the conduc-tor (Figure 1.2 "T"). Singers face the audience so their words are heard directly, as opposed to indirectly, as is the case with the music. The multiple, simultaneous choral voices interweave with one another, yet each has a specific position in the hall. In the center of the space at a level lower than the conductor's platform, a stage presents dancers in front of a blank wall onto which their shadows are projected, emphasizing their silhouettes (Figure 1.2 "S"). Two mirrors flanking the stage at 45-degree angles reflect performers' movements, so spectators see them from three points of view (Figure 1.2 "U"). In Autant's scheme beams of colored light could also be projected into the dome in correspondence with the music to immerse the audience in a visual, as well as sonic, atmosphere (Figure 1.3A).

The acoustic environment that the egg-shaped shell of the Choral Theatre would produce explicitly reveals Autant's artistic intentions. An egg is similar to an elliptical solid, although the geometric focus at the wider of the two ends is not a point but a circle (Figure 1.3B).

Acoustically, such volumes concentrate sound at the geometric foci, creating "hot spots" where the music is unnaturally intense—so much so that acoustical engineers consider any concave, reflective surface in a concert hall to be disastrous for performances of either music or speech. Within a geometric egg like the choral theatre, sounds made near one focal point converge at the other from all directions, so they seem loud and close yet omnidirectional, as if they erupted simultaneously on all sides.

Concave surfaces also reflect sound repeatedly, so tones dwell and mix like echoes in a cave to form a background roar. Similarly, a curved perimeter like the wall of the theatre acts as a "whispering wall," and anyone seated near it hears sound amplified by continuous reflections around the edge. In fact, all listeners seated under a concave dome receive sounds at intensities that vary according to their exact loca-tion in relation to where each voice or instrument originated. Autant's

DOI: 10.1057/9781137368683

A.

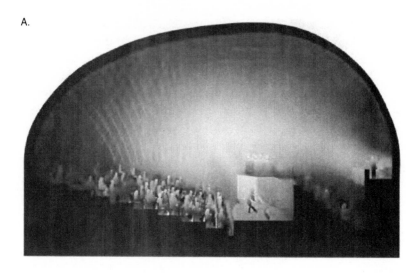

B. C.

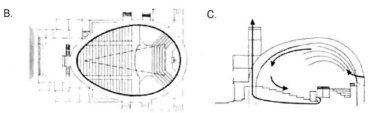

FIGURE 1.3 *A. Cross-section of Autant's Choral Theatre: rendering shows spatial relationships between spectators and actors. B. Plan showing focal points of ovoid form. C. Cross-section showing airflow (Damir Sinovcic and author)*

architectural education emphasized geometric construction, so he may have understood these acoustic issues at least in principle.[11]

In Autant's egg-shaped hall, the acoustical focal point on the wide end is stretched to become a circular plane that encompasses the orchestra, having the effect of fusing the sound together. The acoustical focus at the small end is stretched along the longitudinal axis so that the shell would concentrate the music along its centerline. Audience members seated there would hear the full orchestral sound arriving from all directions, like a sonic atmosphere, whereas listeners in other locations would hear an equally ubiquitous music, but it would be balanced differently, with some pitches dominating others. If a person moved, the balance he or she would hear would shift. The musical mix that each listener heard might interact with the words of the poetry and movements of the dance in a unique way.

DOI: 10.1057/9781137368683

Music performed in the Choral Theatre would have to be composed for the specific conditions created by the hall itself. Art et action's choral performances in their Grenier Jaune in Montmartre presented music by modern composer Arthur Honegger, who may have been sympathetic in theory to a sonically active hall like the Choral Theatre, if not with the difficulties it posed in reality. Honegger wrote music to accompany six poems by Apollinaire in which each element represents a mood or character within the poem that is heard simultaneously with and independently from other elements. For example, his composition "Autumn" evinces fog by a descending sequence of chords, which slides next to a polyrhythm portraying the uneven gait of a peasant leading his ox. Images in the poem and in the music reflect with one another, yet each is separate and their precise relationships remain unfixed. Inside the egg of the Choral Theatre, the three-dimensional qualities of such a piece might be enhanced, as if the sound-images hung in the air.[12]

To reinforce the multi-sensory quality of the music, Autant designed the Choral Theatre to give the encompassing orchestral sound a presence that listeners might also perceive physically. His sketch specified a system of heaters and chillers lining the inner shell to move sound-laden air over and through the audience space like a soft breeze (see Figure 1.2). He noted that the system would "absorb, direct, and distribute the emitted vibrations, joining them together," like sonic weather.[13]

Schematically, outside air enters through a grille immediately behind the orchestra and passes over the musicians, where it is filled with sound (Figure 1.3C). This air is heated by radiators lining the shell and rises to the top of the hall. There, a set of cooling fins chills the air causing it to fall among the audience. The air is then drawn forward to an exhaust grille located just below the stage, which leads to a stack at the front of the building. The stack is the only asymmetrical element of the architectural façade, standing like a sign on the outside as if to announce that something almost industrial is happening within. Perhaps it would even release a sonic smoke.

In Autant's design for a Choral Theatre building, members of the audience would be seated together, facing the conductor; they would likely feel each other's presence more than see it. Rich, resonant music would linger in the air they breathed, while they listened to verses from either side of the theatre arrive crisply and precisely, like words from a pulpit. The audience would be unified, like a congregation in the

FIGURE 1.4 *Score of Panharmonie Orphique performed by Art et action in 1919 (Courtesy: Corti Press)*

Note: The diagonal lines represent sounds that cut through the tonal scale of the song. They are characterized as lightening (L'éclair) and wind (Le vent). "Panharmonie Orphique" is the third episode of Barzun's epic "Orphéide" written in 1913–14.

nave of a church, bound by a shared experience that is felt more than witnessed.

Whereas the Choral Theatre building remained an architectural dream, Art et action performed several pieces of simultaneous poetry in the Grenier Jaune, in which the voices surrounded the audience spatially. In those performances, the distribution of voices allowed a listener to follow verses spoken by one chorus and then shift attention to other voices, to construct a new poem from the confluence of words. For example, in 1922 Art et action performed Henri-Martin Barzun's "Panharmonie Orphique" (Orphic Panharmony), in which a men's chorus, a women's chorus, and a solo voice sang simultaneously.

The small fragment of the poem that Autant included in his description of the Choral Theatre is written as a musical score showing parallel

DOI: 10.1057/9781137368683

voices (Figure 1.4). If this fragment were sung, a listener who followed the words of the soloist in the most direct manner would hear: *"De la Vie, qui s'enfuit, qui bagne nos sens"* (Of life, that flees, that bathes our senses).[14] Below the soloist, the men's chorus sings, *"Qui nous deliverez seule des silences de la mort"* (Who delivers us alone from the silences of death). If the two parts were heard together in sequence, they carry another meaning: *"Qui nous delivrez de la vie seule qui s'enfuit des silences qui baignes de la mort nos sens"* (Who delivers us from the solitary life that flees from the silences that bathe our senses in death). The women's chorus meanwhile adds largely nonsense syllables, which ride above the verse and enrich the sound, with the exception of one insertion—*"divines voix"* (divine voice)—which seems to answer the questions posed by the other two. An alternate reading offers, *"divines voix qui baignes de la mort nos sens"* (divine voice that bathes [perhaps in the sense of cleanses] our senses of death). Each combination of voices yields a distinct poem.

If the piece were sung in the Choral Theatre building, with the men's and women's choruses flanking the stage and the soloist positioned in the middle, as indicated in Autant's sketch, then a listener could shift his or her attention to the left, right, or center to construct the three readings of the poem. Presumably, the lines were repeated so a listener could attend to different parts at each cycle.

Dance added yet another element to Choral Theatre performances. In Autant's building, a dancer's movements would be framed by the motions of the chorus in the same way that the choral music would be surrounded by an atmosphere of orchestral sound. The two mirrors that flanked the stage would multiply the dancer's movements and distribute them spatially. In the mirrors, spectators would see the dancer from multiple points of view, juxtaposed and overlapped like figures in a cubist painting. Multiple views of the same motions also contributed a visual rhythm and repetition to the performance that paralleled its poetic structure. The dance, superimposed on simultaneous verses recited by the chorus and supported by the orchestral music, created complex relationships that the theatre building distributed both around the audience and into acoustical depth.

Synaesthesia

During the 1930s Autant and Lara's interest in the correspondence of sound and sight extended to a study of synaesthesia, or cross-sensory

DOI: 10.1057/9781137368683

TABLE 1.1 *Correspondences between sounds and colors in Art et action's synaesthetic performances and in other poetic and theoretical works cited by Art et action*

	I	E	A	O	U
Art et Action Recitation: The Young Girl, the Old Woman and the Hungry Cow	Young Girl White Flute 3648 cycles/sec la in 6th octave Chord: la,do,mi 6th octave, minor		Old Woman Black Cornet 912 cycles/sec la, 4th octave Chord: la,do,mi 6th octave, minor	Hungry Cow Red Violincello 469 vibrations, ti in 3rd octave. Chord: ti,re,fa 4th octave, major	
Arthur Rimbaud	Red	White	Black	Yellow	Green
Art et Action Recitation: Rimbaud	Red Flute 3648 cycles/sec	White Muted trumpet 1824 cycles/sec	Black English horn 912 cycles/sec	Blue Violincello 456 cycles/sec	Green Bassoon 228 cycles/sec
Albert Ménétreux	Blue	Violet	Red	Orange	–
Phileas LeBeague, 1904 Germaine Arbeau-Bonnefoy	Yellow Flute High do	Orange Trumpet Do- Octave below I	Red Cornet Ti- Below E	Violet Violincello La- Below A	– Bassoon Do – Below O
Horace Hurm	Violet-Red 3648 cycles/sec	Indigo-violet 1824 cycles/sec	Blue-indigo 912 cycles/sec	Green-blue 456 cycles/sec	Yellow-green 228 cycles/sec

DOI: 10.1057/9781137368683

perception. In particular, they compiled research on the experience of specific pitches of sound as colors. Synaesthesia had long been part of symbolist and simultaneous poetic imagery, and several treatises had been written attempting to give the idea scientific weight.[15] Much interest surrounded poet Arthur Rimbaud's 1871 "Le sonnet des voyelles" (Sonnet of Vowels), which established correspondences between specific vowel sounds and colors as he perceived them. In *Art et action* publications, Autant and Lara cited a number of other reported correspondences between colors, musical pitches, the timbres of certain instruments, and the sounds of vowels (Table 1.1).

Experts, however, did not agree on which color was evoked by which sound. *Art et action* considered synaesthesia a logical artistic evolution of simultaneity, a means to touch a deeper level of consciousness, where perception was unified. This dream was shared by many modern artists, including Amadée Ozenfant, a colleague from *Art et liberté* and close associate of Le Corbusier.[16] However speculative, the widespread interest in synaesthesia, recalls the classical relationship between musical harmonies and mathematical proportional systems in architecture.

In 1937 *Art et action* performed Rimbaud's "Le sonnet des voyelles" (Figure 1.5). The piece gave each vowel a voice, a position in the room,

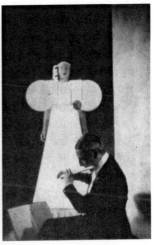

FIGURE 1.5 *Art et action performance of "Le sonnet des Voyelles" by Arthur Rimbaud with vowel costumes in positions around audience and prison scene in double exposure, 1937 (Courtesy: Corti Press)*

DOI: 10.1057/9781137368683

a color, an instrumental timbre, and a character, thereby embodying in real substance the abstraction of language. Performers surrounded the audience, and each spoke lines that stressed a specific vowel appropriate to the pitch of his or her voice. Each spoke from a lectern, which resembled a costume and was lit with the color assigned to the vowel, while musicians struck a note at the associated pitch on an instrument with the designated timbre (Figure 1.5). The sound of word and tone moved from one luminous figure to another around the audience to create sonic poetry in a spatial field.

In the late 1930s, Art et action created several choral pieces for performance on the radio designed to invoke a synaesthetic response in the distant listener. Since a monaural radio speaker could not separate sounds spatially, any sense of space or density had to be contained in the sound itself.[17] According to the synaesthetic theory, which the artists of Art et action had already established, musical pitch could evoke color. A range of tones and timbres, they argued, could paint an imaginary space in warm or cool colors that would suggest depth. Rhythms also could construct a sense of space, or a three-dimensional image, in a listener's imagination. With these sonic elements they composed a virtual architecture through the radio.

Art et action listed five specific kinds of artistic investigation that informed Radiotheatre performances, each linking sound and space:[18]

1 "Individual rhythms": Each person's unique rhythm is revealed in his or her speaking patterns.
2 "Underlying voice": The multiple underlying meanings of words are revealed as they change position in polyphony and simultaneous poetry.
3 "Figurative cadences": A scene or image can be constructed in multiple rhythms moving in relation one another.[19]
4 "Analytical decomposition of sound": Sound can be taken apart into pitch, timbre and duration, which can be manipulated independently like architectural elements.
5 "Simultaneous Harmonies": The sound of words can make correspondences between them even across distant meanings.

These principles are consistent with those grounding other contemporary experiments in spatial music, such as Honegger's compositions to accompany poetry. In radio performances, Art et action used voices to define depth, position, and character. Each voice related to the others

DOI: 10.1057/9781137368683

so a listener could construct spaces and figures in his or her mind across the duration of a piece. In this manner Art et action attempted to sing architecture into being, an idea not at all alien to contemporary poets. In 1931 and 1934, the Paris Opera presented poet Paul Valery's interpretation of the Greek myth of Amphion, a musician who could build buildings by playing his lyre. The poem was set to music by Arthur Honegger and accompanied by a ballet choreographed by Léonide Massine.[20]

Simultaneity and urban architecture

Auguste Perret quoted Valery extensively in an influential statement on architectural theory.[21] The architect's abiding interest in the shape of sound is revealed specifically in his design for the Salle Cortot (1928–9), a small recital hall for the École Normale de Musique in Paris that critics describe as an acoustical gem. Perret wrote that the Salle Cortot would ring like a violin.[22] Built for classical chamber music, the structure resonates with the instruments to shape sound into a series of layers, similar to the sonic composition of Autant's Choral Theatre building.

In the Salle Cortot, listeners hear the first flush of music directly, loud and crisp, because they are seated close to the musicians in a shallow hall on steeply banked rows that surround the wide stage (Figure 1.6). A second sonic layer resonates immediately behind them from walls lined with thin wood panels on battens that vibrate with the music in front of a cushion of air.[23] The hall itself enriches and modifies the music as if listeners were seated inside an instrument. Depending on their positions in the hall, each may hear a slightly different balance of pitch. A third layer of sound surrounds listeners as an atmosphere of background tones. Perret wrote that sound must be given its freedom. He designed the hall to rise high above the heads of the audience and gave the ceiling deep coffers, which hold the low tones a moment longer, creating an ambient hum.

Perret also directed air through the space, employing a system that recalls the one Autant engineered for his Choral Theatre. In the Salle Cortot, air enters through intake vents located behind the stage, moves across the performers, and rises up through the audience to a series of vents in the ceiling and upper wall surfaces, so while spectators watch the music being played, they feel air moving across them, like the breath of sound. Together, these architectural devices create a spatial experience that immerses the audience in multiple sensations of music.

DOI: 10.1057/9781137368683

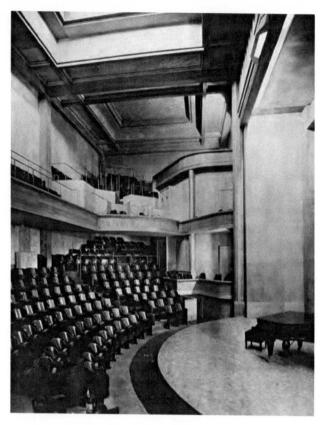

FIGURE 1.6 *Auguste Perret, Salle Cortot, Ecole Normale de Musique 1928–29 (Photo © Estate of Auguste Perret/SAIF, Paris/VAGA, New York)*

In performance, simultaneous poetry and music presented a modern challenge to traditional theatre design; as metaphor, they proposed a new poetic model for the city. Music had long held a position of honor in Paris, a fact celebrated architecturally by Charles' Garnier's monumental Opera House, which opened in 1875. The grandeur of the building and its location at an nexus of avenues elevate the Opera House to an urban role normally reserved for civic or religious buildings. By the 1930s, many left-leaning artists in Paris and Europe in general posited that art should take over the role of religion in expressing moral values and spiritual unity. In more extreme views, theatre was reconceived as an arena of secular ritual, where an assembled audience might share a transformative experience that built a shared identity within a community.[24]

DOI: 10.1057/9781137368683

In the 1930s, Perret presented several urban planning schemes that included monumental public theatres as principle elements. His entry in the 1931 competition for the Palace of the Soviets in Moscow proposed a theatre for 15,000 on the site of the demolished Church of the Holy Savior. Similarly, as part of the planning for the 1937 Exposition of Arts and Industry, Perret redesigned the Chaillot Hill in Paris to include a theatre for 10,000 people, which was not built, as well as several museums, some of which still stand.[25]

Over the course of his career Perret built just two theatres, both before World War II. After the war, he was finally able to complete a major urban design project, rebuilding the bombed-out core of the city of Le Havre on the English Channel. At the symbolic center of the plan, Perret placed a monumental church dedicated to the city's patron saint, St. Joseph. Completed in 1957, the church anchors the center of the city, while its 107-meter tower serves as a beacon that can be seen from the harbor. The hollow, octagonal shaft of the tower rises from the center of the nave, creating a huge vertical volume that makes no sense as architecture, until it is considered acoustically.[26] The interior drum acts as a sound chamber, reflecting the tones of the organ or choir back and forth within it. The effect is a sustained drone, similar to that of a bagpipe, riding behind the music or choral singing of the mass to give the church an atmospheric background chord. At the center of Le Havre, the visual beacon and resonant chord confirms the importance of the church in Perret's urban scheme as gathering place for the population and locus of the spiritual mystery of collective identity. In the tradition of the medieval cathedral, the shared experience of mass performs an urban as well as spiritual rite by making a symbolic link between city and cosmos. The drone of Saint Joseph can be heard as the tone of the heavens, or the music of the spheres channeled through the spiritual heart of the town.

Perret's church of Saint Joseph and the Salle Cortot, as well as Autant's design for the Choral Theatre, brought acoustic strategies into urban significance by proposing spaces in which audiences could come together to share an intense, poetic immersion in sound, parallel to the ritual of mass. All of these buildings create sonic atmospheres that surround listeners collectively, then speak to them individually by separating tones, amplifying some and dampening others in each specific location to add a spatial dimension to auditory experience. With resonant panels, whispering walls, and howling towers, they pressed the

DOI: 10.1057/9781137368683

limits of architectural acoustics to create a physical experience of sound. Proposing these buildings for the city, Perret and Autant reinterpreted an ancient spiritual and architectural tradition that wends from the Greek chorus singing in the ritual of Dionysus, and the monastic chant tuned to the resonant frequencies of the chapel, to the choral hymns of Catholic mass emanating from the cathedral and the arias performed in the Paris Opera house. Both architects offer a modern definition of spiritual ritual based in the multiple voices of choral poetry. That ritual is collective, resonant, and atmospheric, and is located at the heart of a town as it is in the center of Autant and Lara's quintology of dramatic space.

Notes

1. Sebastién Voirol was the pseudonym of poet Gustav Henrik Lundquist (1870–1930). "Le Sacre du printemps" was performed in 1913 in Paris by the Russian Ballet under the direction of Sergei Diaghilov with music by Russian composer Igor Stravinsky (1882–1971).
2. Corvin, *Le Théâtre de recherche entre les deux guerres: Le laboratoire Art et Action* p. 74.
3. Art et action embraced broad ideas of artistic simultaneity in modern experience, which were based in the philosophy of Henri Bergson and championed by Apollinaire. See discussion in Introduction of this volume.
4. Corvin describes the negative reaction of the reviewer, who called the performance cacophony. Corvin, *Le Théâtre de recherche entre les deux guerres: Le laboratoire Art et Action* p. 75. 1919 was same year Art et action separated from Art et liberté and only two years after the debut of Voirol's poem.
5. Art et action, *Cinq conceptions de structures dramatiques modernes* p. 9.
6. Barry Blesser and Linda-Ruth Salter (2009) *Spaces Speak, Are You Listening?* (Cambridge, MA: MIT Press) p. 92.
7. Art et action, *Cinq conceptions de structures dramatiques modernes*. See section on Théâtre Universitaire, page 8 under heading "Analyse de Quintologie de Conceptions de Structures."
8. Alberto Perez-Gomez has written extensively on "choros" as an ancient model for both theatre and architecture. See especially Alberto Perez-Gomez (2006) *Built Upon Love* (Cambridge, MA: MIT Press) pp. 44–56.
9. Craig, *Towards a new theatre: forty designs for stage scenes* p. 8.
10. Fernand Divoire in *Vie des lettres* quoted in Corvin, *Le Théâtre de recherche entre les deux guerres: Le laboratoire Art et Action* p. 38. Poet Henri-Martin

DOI: 10.1057/9781137368683

Barzun (1881–1973), who worked with Art et action described his poetic doctrine as "Simultaneiste." See discussion in Introduction.

11 Autant graduated from the Ecole des Beaux Arts in 1900. This classical education in architecture included extensive instruction in constructing geometric forms. See Arthur Drexler (1977) *Architecture of the Ecole des Beaux Arts* (NY: Museum of Modern Art).

12 Autant also used music by Arthur Honegger, in performances of his "Le dit des jeux du monde" (1919), "Le dance macabre" (1919), and "Le Douzieme coup de minuit" (1933). Honegger's music was recorded on CD in France by Timpani in 1992. For more on the composer, see www.lawrence.edu/fac/koopmajo/honegger.html.

13 Art et action (1938) "Le Théâtre choréique," *Architecture d'aujourd'hui*, 9/9 (September 1938), 40. This suggests a poetic concept of the speed of sound (344 meters/sec) relative to the speed of convection (less than 1 meter/sec).

14 Art et action Théâtre choréique in Cinq conceptions, unpaginated.

15 Art et action cited an extensive bibliography of sources dating from the late nineteenth century to 1920 in Art et action (n.d.-a) *Synesthesie* (Paris: Fond Art et Action, Archive des Arts du Spectacle, Bibliothéque Nationale de France).

16 Ozenfant introduced Le Corbusier to painting and color theory. See: William Braham (2002) *Modern Color/Modern Architecture: Amadée Ozenfant and the Genealogy of Color in Modern Architecture* (London: Ashgate).

17 If the broadcast is sent and received in stereo, then the two tracks could be distinguished.

18 In Art et action, *Synesthesie*.
 1. *Rythmes Individuels: recherche de la révélation de chaque personnage par son rhythme verbale.*
 2. *Vois sous-jacentes: recherche de la signification du sujet par amplificaion polyphonique ou simultanéisme.*
 3. *cadences figuratives: recherche du décor sonore realistique ou image, par le rhythme des dynamismes evoqués.*
 4. *Décomposition analitique du son: recherche de la reconstitution des valeurs sonores par l'enchainement des éléments décomposés.*
 5. *Harmonies simultanées: recherche des liaisons sonores par groupes particuliers d'accords verbaux.*

19 For example, as jazz rhythms merge and separate they suggest spatial depth or three-dimensional form. Some specific cadences, such as a heartbeat or a march, also make specific figural references. Recall how Honegger rhythmically evoked the ox.

20 Ambroise-Paul-Toussaint-Jules Valéry (1871–1945) French poet, playwright, and essayist. Paul Valery (1967) "Amphion," *Paul Valery Plays* (Paris: Gallimard). Honegger's musical adaptation of "Amphion" debuted in 1931 with a ballet choreographed by Léonide Massine (1896–1979) Russian

DOI: 10.1057/9781137368683

choreographer for Sergei Diaghilev's Ballets Russes. Correspondences between music and architecture, whether synaesthetic or not, have an ancient history. In radiotheatre, Art et action explored the limits of artistic correspondence between sound and space as an extension of their experiments in choral performance.

21 Perret, *Contribution a une théorie de l'architecture.*

22 The full quote is from the client, pianist Albert Cortot, who wrote upon completion of the building in 1929, "Il nous avons dit, 'Je vous ferai une salle qui sonnera comme un violon'. Il a dit vrai. Mais il se trouve—ce qui dépasse nos espérances—que ce violon est un Stradivarius." (He told us, "I will make a hall that will ring like a violin." He spoke the truth. But I find that it has exceeded our hopes. This violin is a Stradivarius.) cited in Karla Britton (2001) *Auguste Perret* (London: Phaidon) p. 73. and in Marie-Christine Lauroa, Laure Beaumont-Maillet, and Jean Colson (1992) *Dictionnaire des monuments de Paris* (Editions Hervas; Berkeley, CA: University of California Press) p. 208.

23 Auguste Perret (1938) "Le Théâtre," *Architecture d'aujourd'hui*, 9/9, 2–12, p. 9. Perret described the sound of a chorus of pilgrims singing under the trees at Lourdes. He wrote that the beautiful sound was made in the space between the ground and the covering of leaves. He concluded that to create an equivalent sonority, a hall must be perforated in the same proportion of the leaves. He wrote that he designed the inner wall of Salle Cortot as a basket creating a cushion of air between it and the outer shell, which condensed and amplified the sound.

24 For the range of discussion on the role of art in a communist society, see, Maynard Solomon (ed.) (1979) *Marxism and Art* (Detroit: Wayne State University Press).

25 Britton, *Auguste Perret* p. 208. Perret and Le Corbusier were among nine architects invited to compete for the Palace of the Soviets commission. Perret published the plan for the Chaillot Hill in a special edition of *L'Architecture d'Aujourd'hui* in 1932.

26 Britton, *Auguste Perret* p. 90.

DOI: 10.1057/9781137368683

2

The Festival of Seeing Others and Being Seen: Theatre of Space

Abstract: *Autant and Lara built a Theatre of Space for the 1937 International Exposition in Paris, which modeled the experience of a modern public square. In performances, five simultaneous scenes both surrounded and were surrounded by the audience to summon the multiple elements of a festival. Architectural techniques of layered space, silhouette, and false perspective heightened actors' movements visually, while cinematic techniques of montage and panorama were transposed into live theatre. Similar strategies appear in the design of modern public spaces, such as Perret's proposal for Porte Maillot and several buildings designed for the 1937 exposition such as the Palais de Tokyo and Place de Chaillot. Popular festivals in public space were community events that Autant and Perret would consider essential to modern, collective urban life.*

Read, Gray. *Modern Architecture in Theatre: The Experiments of Art et Action.* New York: Palgrave Macmillan, 2014. DOI: 10.1057/9781137368683.

In 1917 *Art and liberté* performed Guillaume Apollinaire's "surrealist" play *Les Mamelles de Tirésias* (the Breasts of Tiresias), a story of the female part of the Theban seer, which sought true equality with the male.[1] In the prologue, Apollinaire wrote that the play was like a festival and should be performed in a new kind of performance space:

> Circular theater with two stages
> One in the middle and the other like a ring
> Around the spectators permitting
> The full unfolding of our modern art
> Often connecting in unseen ways as in life
> Sounds gestures colors cries tumults
> Music dancing acrobatics poetry painting
> Chorus's actions and multiple sets.[2]

As performed, the play assaulted spectators with multiple simultaneous events, supporting Apollinaire's contention that art's most powerful moments are not lodged in premeditated form but ignite between disparate things in the imagination of the spectator.[3] He wrote that art, theatre, and architecture should neither mirror nature nor construct an ideal, but draw back the veil of the ordinary to reveal deep poetic resonances that link seemingly separate phenomena.

Art et action's second conception of dramatic structure, the Theatre of Space built on this vision both in performance and architecture to create potent juxtapositions not of form but of action. Edouard Autant and Louise Lara invoked Apollinaire's acrobatic festival in Theatre of Space performances that comprised multiple simultaneous scenes surrounding and surrounded by the audience. In contrast to the Choral Theatre, Theatre of Space performances were visual more than auditory, and in place of poetry, the principal dramatic form was improvisation, tending toward mime.[4] Performances presented multiple scenes of spontaneous, gestural acting and choreographed dance in a juxtaposition that slowly revealed a larger mythic order.

In 1933 Autant sketched plans, sections and an elevation a Theatre of Space building that draws on a Russian constructivist idea for an "environmental" theatre. His scheme shows a raised ring stage that would surround spectators with the action of the play, as well as locations among the audience for small, intimate scenes. Five years later, Autant was able to build a Theatre of Space performance hall inside a larger building constructed for the 1937 Paris International Exposition of Arts and Technology. Autant wrote a cycle of plays and designed sets for

DOI: 10.1057/9781137368683

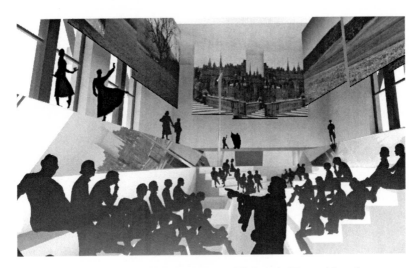

FIGURE 2.1 *Interior view of Theatre of Space (Théâtre de l'Espace) based on sketches by Edouard Autant (Eduardo Luna and author)*

Note: Actors play in lower area between audience bleachers and on upper surrounding stage. Tilted mirrors reflect action behind spectators. See also image link: http://figshare.com/articles/2_2isometricJuly13_tif/771964 Isometric view of Theatre of Space.

the space, whereas Louise Lara trained a troupe of actors in improvisation techniques, the Comédie Spontanée Moderne. Together Autant and Lara directed the performances. Five independent, simultaneous scenes included two improvised skits at the center of the hall in between banks of spectator seating and three choreographed scenes to take place around the audience (Figure 2.1).

The spatial position of each scene defined its role in the story and created moments of contact with other scenes that opened to imaginative interpretation by both actors and audience. Contrasts of position between high and low, near and far, generated dramatic opportunities for actors who were trained to respond in expressive gesture and movement.

Performances placed the audience in between genres of art, including music, poetry, drama, and dance. Each scene engaged spectators differently, dividing their experience among the senses so what they saw was distinct from what they heard, or from a narrative storyline that they followed. Spectators cast their attention from one scene to another to construct poetic concordances between sights, sounds, and narrative, such that the experience of the play was not controlled by an author but built in the imagination of each spectator from the fragments that he or she heard and saw.

DOI: 10.1057/9781137368683

The spectators' experience of these performances in the hall that Autant designed for them recalled the tradition of popular festivals in public space and remade them for a modern, collectivist city. In particular, the spatial order that the Theatre of Space building gave to the performances can be read as a proposal for how a modern public space could give poetic order to urban events.

The design of the Theatre of Space

For the 1937 Exposition, Autant built a rectangular hall 50 meters in length, with a large stage that surrounded the audience on three sides. The containing walls were pierced with glazed doors and windows that reached from the floor of the stage to a high ceiling, and most of the roof was a skylight that could be opened in good weather, releasing the hall to the sky (Figure 2.2, "L").

In the earlier sketch for the Theatre of Space building, Autant designated the perimeter of the hall as a "transparent atmospheric band," which would be open to fresh air (Figure 2.2, "A"). The plan shows the audience divided into banks of bleacher seats that faced one another, with small spaces between them for performers (Figure 2.2, "F" and "D"). The section shows the surrounding stage raised above the highest level of the seats, and scenery hung still higher, above the heads of the actors where it would not obstruct a view out to the landscape (Figure 2.2, "P").[5] The section and elevation show a retractable ceiling operated by a system of counterweights, which are visible on the outside, so passersby could discern whether the ceiling was open or closed (Figure 2.2, "L" and "C").[6] Between the audience and the panoramic stage, Autant's sketches show long, tilted mirrors that would allow spectators to see action on the stage behind them in reflection (Figure 2.2, "R"). This device did not appear in the built project, however one commentator noted that the seats swiveled and were outfitted with some sort of rear-view mirrors.[7]

The architecture of the theatre as experienced in performance presented spectators with several simultaneous scenes at graded layers of distance, including a view of others in the audience, as well as views to the real landscape outside, the painted landscape of the scenery, and the sky (Figure 2.3). Each of these scenes had a role in the spectator's experience. The most intimate and improvised performance took place on the lowest level amidst the audience, where actors worked

DOI: 10.1057/9781137368683

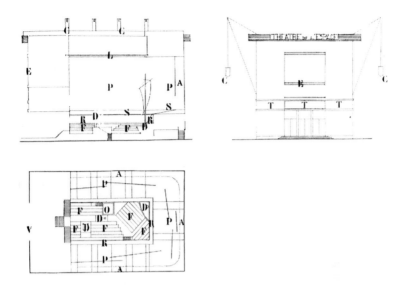

FIGURE 2.2 *Theatre of Space Plan, section and elevation drawn by Edouard Autant, 1933 (Courtesy: Corti Press)*

Note: Plan shows bleachers for spectators in the center surrounded by a large raised platform stage. Section shows bleachers, raised stage, suspended scenery, retractable ceiling and skylights. The mast and sail were props for "*Les Prévisionnaires*" 1932. Elevation shows counterweights for retractable ceiling and projection screen Moveable ceiling accommodated air and weather protection. Key: Transparent Atmospheric Band open to fresh air (A); Counterweights for moveable ceiling (C); Improvised Scenery (D); Closed-circuit television screen showing performances in progress (E); Seating for Audience (F); Moveable ceiling for fresh air and weather protection (L); Orchestra funnel (O); Panoramic Stage (P); Mirrors (R); Entry Hall (V); Advertising Posters (T).

intuitively from a minimal script to create familiar characters, for example, a husband and wife or a tutor with students.[8] At such close proximity, actors had to be realistic and precise, using natural gestures, subtle facial expressions, and colloquial language that was intimate and nuanced. Spectators could read every change of expression, notice the stitching of the clothing, and watch an actor's muscles move under the skin. Face-to-face, spectators saw actors as real people first and as characters second.

Behind the actors, spectators looked across to the other bank of seating to see others in the audience facing them. At this distance, they could read expressions of other spectators and would be aware of being seen by them. In the strong light from skylights above and in full view of the

DOI: 10.1057/9781137368683

A. B.

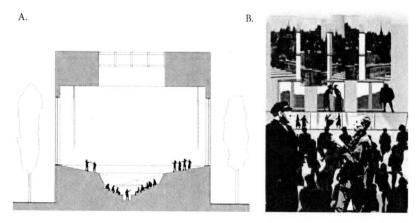

FIGURE 2.3 *Cross section of Theatre of Space, based on Autant's sketches and photos of the built hall*

Note: A. Cross-section showing relationships between spectators and actors. Dotted lines show the view reflected in the mirror. The tilt of the upper stage floor approximates the view-line of spectators so they would see the full bodies of the actors superimposed against the windows; B. Spectator's view, showing seven layers of action: improvisation actors immediately in front, a bank of spectators in facing bleachers, scenes on the upper stage, a scene reflected in mirror, a view out windows to landscape, scenery of the play, and a view to the sky through skylights.

actors and each other, spectators played their roles by responding to the action spontaneously.

Beyond the facing bank of spectators and further away, they would see a choreographed scene on the upper stage. Turning to the side, they would see another scene on the upper stage, and a third would be active behind them reflected in the long mirror so it would seem quite distant. Autant wrote that scenes on the upper stage, in contrast to those below, should be choreographed to create an overarching rhythm.[9] There, actors performed in a theatrical style, moving in rhythmic dance, song, or chant to create visual panoramas and atmospheres of sound. They appeared with scenery above them as well as a view through the windows to distant trees and buildings. In this upper realm, dancers and choruses moved freely around the audience in an expansive world that extended into the city and the landscape. Autant's sketched section shows the stage floor sloped to create up-stage and down-stage positions. However, the effect was opposite that of a traditional stage. The stage was banked such that the angle of the slope approximated a

DOI: 10.1057/9781137368683

FIGURE 2.4 *Theatre of Space, rendering based on Autant's plan and section (Eduardo Luna and author)*

Note: Rendering shows light from skylights and scenery on upper stage. The mast and sail were indicated in a model for a shipboard scene of "Les Prévisionnaires" 1932.

spectator's line of sight; therefore, the floor would not be visible and actors' positions in depth would be difficult to gauge (dotted lines in Figure 2.3A). Actors would seem superimposed on one other, particularly when moving against the brightly lit windows behind them. Thus silhouetted they would seem two-dimensional and almost weightless, their faces rendered invisible.[10]

Well above the actors' heads, spectators would see painted scenery. Detached from the action, it acted as a symbolic indication of a fictional place rather than a believable illusion. The fictional locale suggested by the scenery was juxtaposed with a view out the windows to the city, which reminded spectators of their real location on the Champs de Mars under the eye of the Eiffel Tower. The open ceiling allowed a view of the sky that established the play's ultimate position under the heavens, a position the script sometimes mentioned directly (Figure 2.4).

This set of scenes layered in depth, which was created by the architecture of the Theatre of Space, recalls the simultaneous experiences one might encounter in a city square: intimate café conversations that unfold spontaneously, an awareness of being seen while watching others at a social distance, and the still more distant promenade of people

DOI: 10.1057/9781137368683

going about their business in the city. Traditional public squares are surrounded by architectural façades, which often offer classical columns and a demeanor that invokes a stately or romantic elsewhere. The buildings can be read as urban scenery with a narrative that adds to the events of the day, yet they remain real buildings that order the work-a-day life of the city. They cast shadows that move with the passage of the sun, and they frame views out to the surrounding landscape and up to sky.

In the parallel world of the theatre, Art et action heightened the formal qualities of this urban experience, presenting performances in which conversations more vivid, distant scenes more composed, and the views of landscape and sky more lyrical. The scenes were layered spatially as if the city were compressed. Performances also made connections between the scenes, so words and gestures in one were answered in another beside or behind it to build a web of correspondences that reflected poetically on similar correspondences one might encounter in the city.

If urban life is considered a performance, then the chance encounters, casual conversations, negotiations, and confrontations of daily life are experienced as improvised actions made up on the spot spontaneously, whereas the promenade of others going about their work appears in rhythmic orderliness that supports and defines the city. Autant wrote that the scenes set among the audience were "destined to receive the public and to comment on, analyze and link the action of the public to a universal action."[11] In other words, the improvisation of the Comédie Spontanée actors was intended to forge the spiritual link between the daily lives of spectators and the choreographed performance proceeding on the upper stage, revealing resonances between open-ended individual experience and the higher, spiritual order of the world.

Autant's texts play on the boundary between upper and lower realms, defining moments of particular transformation when characters step from one into the other. In a play he wrote for the Theatre of Space, *Les Prévisionnaires* (The Innovators), for example, the upper stage holds three independent scenes: two shipwrecked sailors enter a cave and are attacked by a bear, villagers enjoy a festival (largely enacted in mime by the Comédie Spontanée), and a sheepherder in a field whistles a few notes of jazz on his flute, which signal the orchestra to play a pastoral symphony. The two lower stages hold intimate, quotidian scenes: a sailor and cabin boy have a disagreement on board a ship, and a journalist returns to his wife who is just getting out of bed. The two dialogues

DOI: 10.1057/9781137368683

on the lower stages are interlaced in words that volley from one to the other, each in the contexts of their separate situations, ending in an echoed "why do it? / why do it?" Suddenly, all scenes are interrupted by an SOS call for help sent by the sole sailor surviving the bear. All characters pause to listen, then one by one each responds to the cry from within their various narratives. The leader of the village assembles a scout troop and talks importantly about heroism but remains in the village, while an old man quietly goes to aid the castaway. The shepherd remains with his sheep. Both the journalist and the cabinboy leave their respective scenes and their lives to appear on the upper level in the scene of the shipwreck. In moving from lower to upper stage, they join one another to become a chorus, which appears in silhouette. All chant the moral of the play:

> There are those who succeed and those who fail; those who fail, like the dead in relation to the living, are much more numerous. However, some that fail enrich human thought. Let us glorify those who fail and encourage them for it is they who create life. I will try again, he will try again, we will try again, to persevere, to persevere.[12]

The chorus is rhythmic and grand, addressing the audience in poetic words that resonated with the ancient tradition of theatrical speech.

Spatially, the upper realm juxtaposes scenes that act on each other across a distance both real and symbolic. The castaway sends his SOS in the language of a telegraph—a modern medium. The village festival and the actions of the scout troop under its bombastic leader can be read as conventional rituals and characters, which are revealed as ineffectual. The shepherd's music on the other hand rings true, establishing the rhythm of the play as a whole.

The main action in the play is the transformation of the journalist and the cabin boy, who rise to join others, changing their words from prose to poetic chant. The SOS represents a call of inspiration or duty that some heed, leaving their lives behind, and some do not. Some do not need to answer the question, "Why do it?" They simply go because they are called. They shed familial identities to take roles in the larger performance, where they speak a larger truth.

Les Prévisionnaires was the first of a projected six-part cycle of plays that Autant wrote to be performed in the theatre of space. Two of the plays are preserved and were performed in Autant's Theatre of Space during the 1937 exhibition.[13] *Les Prévisionnaires* introduces the trope of

DOI: 10.1057/9781137368683

spiritual calling, which elevates ordinary people out of their improvised lives to become part of a spiritual elite that links the world of the everyday with the order of the cosmos. The second play, *Les Métaux* (The Metals), carried the game further to specifically link the building crafts to cosmic unity. In this performance the craftsman at the forge worked transformative magic. The art of forging metals from the earth to create the artifacts of human life summoned classical alchemical correspondences between the planets and the various metals. The sun was associated with gold, the moon with silver, Mercury with mercury, Venus with copper, Mars with iron, and Jupiter with tin. In one scene, dancers gave gesture and motion to the elements, dancing to Wagner's "Incantation of Fire." Meanwhile, in an adjacent scene a grizzled blacksmith instructed a young apprentice. Beams of light in gold, silver, and purple moved on panels behind them in undulating patterns following the rhythms of their bodies. If *Les Metaux* were performed at night in the Theatre of Space, through the open roof, perhaps spectators could have seen the moon.

Environmental theatre: improvisation and cinema

Theatre of Space performances offered an architectural alternative to the vicarious experience of theatre or cinema. Instead of sitting in a darkened hall, spectators engaged the story as it played out all around them in daylight or under the stars in full view of each other and of their surroundings within the city. In this sense, plays in the Theatre of Space recalled ancient epic dramas staged outdoors in natural landscapes or in city squares, where the moral and spiritual dilemmas explored in the story were enacted within the settings of civil society and under the heavens.[14]

In a description of the Theatre of Space, Autant invoked Renaissance drama in which actors embellished or commented on the text and sometimes left the stage, "creating an atmosphere of contact with performance that escaped the constraints of an arbitrary division, to allow actors and audience to participate in an event."[15] He also cited seventeenth-century plays written so that a patron or lord could play a role extemporaneously. Both of these examples broke the envelope of the story by letting actors and spectators speak both in their roles and outside of them simultaneously.

DOI: 10.1057/9781137368683

The tradition of transgressing the bounds of the story and engaging spectators directly emerged in progressive theatre by directors such as Vsevelod Meyerhold in Russia and Erwin Piscator in Germany.[16] Meyerhold and Piscador worked with architects El Lissitzky and Walter Gropius, respectively, to design environmental theatres that would immerse the audience in the play surrounding them with the action. Meyerhold wrote that spectators should no longer stand at a distance from an enframed fictional world, however much they might experience the story vicariously, but should recognize the actors as real people acting purposefully in the world, like any other worker.[17] The purpose of such performances was not fantasy or escape, but to share meaningful stories, parables, or allegories that have a real effect in the world.[18] This role for drama was particularly pointed in post-revolutionary Russia where theatre specifically strove to engage citizens in revolutionary cultural dialogue.[19]

Autant and Lara followed Meyerhold's work closely and knew El Lissitzky's 1925 model for a hall surrounded by ramps for actors in motion.[20] They traveled to Poland in 1933 to see the work of architect Szymon Syrkus and theorist Zygmunt Tonecki, including the remodeling of an existing theatre to distribute scenes through the audience space and a scheme for a huge "Simultaneous Theater" with a moveable stage[21] (Image link: http://www.theatre-architecture.eu/db.html?theatreId=917). For the design for the Theatre of Space, Autant drew on Syrkus and Tonecki's spatial ideas and Meyerhold's social agenda, merging them with Apollinaire's original artistic vision of multiple, simultaneous scenes in several genres of performance, particularly improvisation.

For her part, Lara trained the Comédie Spontanée Moderne in improvisation, the "ardent and passionate life of the theatre in search of its supreme expression."[22] She devised a three-year regimen to teach actors to react instantly and honestly to fictional scenarios played in relation to real spatial relationships. Actors learned to take roles by drawing on intuition and natural physical responses to each other and to the spaces they inhabited. In training, they enacted folktales such as Fontaine's fables that, Lara held, expose the raw characteristics of human nature: qualities of Everyman that invoked actors to reach past individuality to plumb the universal soul. Lara wrote, "For the acting to be truly spontaneous, the player must talk, feel, sense, react, express and have attitudes that conform with the character." She explained

DOI: 10.1057/9781137368683

that actors should act with their whole bodies and their whole spirits, in unison with the character they inhabit, so that fiction becomes a means to honest expression.[23] "They must act fully in space until the actor ceases to be a voice and becomes a gesture. Thus a theatre of authors must give way to a theater of actors, and dramatic literature give way to scenic action."[24] In Lara's improvisation exercises actors inhabited fictional characters physically by acting honestly in their own bodies in real, architectural space. This double awareness on the part of both spectators and actors was central to Autant and Lara's larger vision.

The same interlacing of physical reality with narrative also defined the Theatre of Space as a modern theatric form that might resist the burgeoning popularity of cinematic spectacle as well as the march toward a passive mass society that it represented. The dream that theatre might take back from cinema the popular audience it had lost was also embedded in Theatre of Space performances, particularly their spatial staging, which could deliver some of cinema's visual effects in live theatre. For example, the five scenes distributed throughout the hall played simultaneously, but only one actor spoke at a time. Spectators' attention could be drawn from scene to scene reliably, as in the parallel repartee of the journalist and cabin boy in *Les Prévisionnaires*. Phrases traded between skits would snap spectators' attention from one to the other and back again. Thus mingled, the two conversations and the two scenes implied a third level of meaning, like montage in cinema yet lodged in real space. Similarly, the surrounding stage presented a panorama that spectators could survey as a camera might scan across a landscape, or they could follow a character, such as the old man from the village, moving from scene to scene as in a tracking shot. In the cinema, these camera effects separate a viewer's active eye from a passive body, whereas in the theatre they reinforce the spectator's bodily presence.

During the 1920s, cinema deeply challenged theatre as an art form. It gravely cut into theatre's audience to the extent that many modern playwrights and directors scrambled to find new techniques that might prove immune to encroachment. Russian director Nikolai Pavlovich Okhlopkov, a student of Meyerhold and colleague of Tonecki, championed the spatial potential of environmental theatre to liberate performance into three dimensions and leave the flat cinema screen behind. Okhlopkov wrote that environmental theatre frees a

DOI: 10.1057/9781137368683

performance in several ways. Spatial theatre discards the box stage and may use the entire auditorium for performance. It allows the audience to surround the stage as well as the stage to surround the audience. The audience's attention may be drawn from one area to another at any time in montage juxtaposition. And theatre by nature requires a different kind of acting based in intuitive rapport with the spectators and in poetic language.[25] Half of these principles draw explicit similarities between environmental theatre and cinema, while the other half define how live theatre on such a stage can surpass cinema. Okhopkov notes that a character in cinema cannot leave the frame of the projector to walk among the audience, nor reinterpret a scene, nor interact with spectators face to face. The audience can never surround a cinematic projection or see the back of it. And in cinema the "genuine language of the theater," meaning grand, poetic speech, never seems anything but stilted. In light of Okhlopkov's analysis, the Theatre of Space offered an alternative to cinema by creating cinematic experiences architecturally.

For all this, Art et action embraced the technology of cinema and radio in their performances, not as ways to disseminate their art, but as potent way to extend the action in time and in place. Autant's sketch for the design of the Theatre of Space included a large screen on the building façade so performances in progress inside could be projected by closed-circuit television (see Figure 2.2, "E").

This technology was wishful thinking at the time, however it embodied a nineteenth-century idea of *architecture parlante*, that a building's façade should "speak" honestly, revealing its interior. The projection screen on the street façade suggests that the building might speak not of its material reality or structural form but of its interior events.[26] The screen allowed the theatre, which faced a public square, to add to the life of the city by introducing another scene, thus creating new opportunities for sparks of contact with the people and activities already there.

If Autant's projection screen was never built, Robert Mallet-Steven's was. Mallet-Stevens, a younger architect who knew Autant and Lara's circle and had worked in cinema alongside their son Claude, built a large projection screen on the façade of his Electricity and Light Pavilion for the same 1937 exposition in Paris that saw the Theatre of Space.[27] The screen faced the terrace of the Chaillot Palace, where many people gathered on their way to the fair. Images projected at night took a position as part of urban life, not closeted away in a dark hall. They became

DOI: 10.1057/9781137368683

one scene among many that visitors to the fair might encounter as they walked and talked together.

Modern city plaza

Autant and Lara shared Meyerhold's view that theatre could offer a vision of modernity in advance of reality.[28] Their Theatre of Space performances, integrating architecture and action, can be read as a proposal for how modern urban life might play out in a plaza designed for a collective society. Reaching back to Apollinaire's vision of a festival in public space, Art et action's performances propose a spatial order that gives a position for each player, from Everyman on the plaza floor, to artists following a spiritual calling on the upper stage, to the landscape, and the heavens beyond. The broad hierarchy of the performances gives new form to the popular street festival by elevating the arts without losing the complex skein of multiple voices.

The Theatre of Space architectural design also stands in contrast to classical theatres and to classical urban spaces. In both theatre and plaza, classical architectural design offers a large area for spectators but a relatively small raised stage or axial focus for performers clearly separated from the crowd. Urban plazas, in particular, define public life through a sharp hierarchy. The population is held at ground level whereas a privileged few, kings and popes, are elevated and enframed architecturally. Their words resonate and their movements appear larger than life. Theatres mirrored urban squares by separating a large audience from few actors who spoke eloquently from a script written by an invisible author.

In the Theatre of Space, Autant and Lara proposed an alternate situation that modeled a different social hierarchy. The space and performance still distinguished a lower and upper realm, yet the raised stage included many different kinds of action by many different authors. The multiple scenes were equally weighted in importance yet presented different genres of action with no single focal point. In addition the boundaries between the lower and upper realms were permeable enough to allow, indeed celebrate, movement between. A word or action on the lower stage could affect actions on the upper stage, and stories often involved characters who traversed from one to the other to assume new roles. Finally, all action was clearly situated in locale, anchored to the city and to the sky, both physically and symbolically. As a model for public life in

DOI: 10.1057/9781137368683

FIGURE 2.5 *Perret's sketch of Porte Maillot, 1930 (Credit: Art © Estate of Auguste Perret/SAIF, Paris/VAGA, New York)*

Note: Even in a sketch, Perret shows how the space would be occupied.

a modern society, the implications are clear. Every person contributes to one or another aspect of a diverse urban life, and some are called to act at a more significant level within the social rhythms of the city and the natural rhythms of the cosmos.

If the Theatre of Space is understood as part of the contemporary discussion on the emerging nature of modern urban life and the design of public space, then Autant and Lara's ideas align with those of their colleague Auguste Perret. In the early 1930s, Perret proposed new urban plazas in competition schemes for the Porte Maillot in Paris and the Palace of the Soviets in Moscow (Figure 2.5).[29] In each, Perret's plazas were grand in scale, yet ringed with raised terraces and walkways, where the rhythmic life of the city would come into view. For the Porte Maillot, Perret sketched several layers of activity: a street with fast cars and buses, a semi-circular plaza for pedestrians, and at least two other levels of walkways that link large buildings and overlook the plaza.

DOI: 10.1057/9781137368683

His sketch shows the plaza occupied at every level with people who would be able to see one another going about their regular business. In the scheme for the Palais of the Soviets, Perret proposed a large plaza surrounded by buildings with windows and terraces, where people could overlook the space and be seen by those below. In addition, the plaza opens toward the Moskova River, providing views that frame the city and the landscape.

Autant and Lara's Theatre of Space performances and Perret's schemes for urban plazas also presented a clear proposal for the position of the modern spectator in public space. In performance and in architecture they located spectators within the scene where they would see each another directly and would be seen in turn as part of the action. In that position, spectators might gain a small shiver of self-consciousness, caught in the act of watching each other watching.

Autant and Lara's Theatre of Space articulates the layers of urban activity in miniature. The plays Art et action presented during the Paris Exposition of 1937 surrounded spectators with sights and sounds and challenged them with improvisation, all in the spirit of a festival in a town square. Performances revealed the creative inspiration of individuals called to act in the collective arena, each contributing in his or her own capacity to move a shared narrative forward. Autant and Lara reinterpreted ancient traditions of open-air drama to propose a model for modern public space, in which architecture made the multiple experiences of urban life visible, giving the city physical as well as symbolic meaning.

Notes

1 Corvin, *Le Théâtre de recherche entre les deux guerres: Le laboratoire Art et Action* p. 76.

2 Apollinaire, "Breasts of Tiresias" in Jacques Guicharnaud (ed.), (1961) *Modern French Theatre from Giradoux to Beckett* (New Haven: Yale) p. 66.

3 Arnold Aronson (1977) *The History and Theory of Environmental Scenography* (Ann Arbor: UMI) p. 19. Frederick Kiesler drew an "Endless Theatre" in 1923 and designed a "space stage" for the 1924 Vienna Music Festival. Walter Gropius designed a "Totaltheatre" for director Erwin Piscator in 1927. El Lissitzky designed a surrounding stage in 1926 for Vsevelod Meyerhold for an unrealized production of "I Want a Child" by Tretyakov.

4 Autant described the Theatre of Space, and explained his intentions and precedents for the design in Art et action, *Cinq conceptions de structures dramatiques modernes*, n.p. Art et action also collected manuscripts for the

DOI: 10.1057/9781137368683

plays, correspondence, and photos of the building in a scrap book *Art et action,
Théâtre de l'espace,* Folio 27, Fond Art et Action, Archive des Arts du Spectacle
Bibliothéque Nationale de France, Paris.

5 The theatre is described with some photos of construction in Art et action,
 "Théâtre de l'espace" Folio 27.

6 The built project had operable skylights but not the system of counterweights
 that would open the ceiling and skylights completely.

7 Corvin, *Le Théâtre de recherche entre les deux guerres: Le laboratoire Art et Action*
 p. 300.

8 Both of these scenes were part of typescripts written by Autant for Theatre of
 Space performances. Art et action, "Théâtre de l'espace" Folio 27.

9 See section on Théâtre de l'espace in Art et action, *Cinq conceptions de
 structures dramatiques modernes.*

10 In a 1929 performance of "Cain" by Lord Byron, Autant built an upper
 platform for celestial scenes and specified that a skirting board should hide
 the actors' feet so they would appear suspended in air. Art et action (n.d.)
 Cain, Fond Art et Action, Archive des Arts du Spectacle, Bibliothéque
 Nationale de France (Paris) p. 30.

11 He went on to invoke Corybant, priest of the Phrygian goddess of nature,
 Cybele, known for ecstatic dance, spontaneous movements inspired by the
 spiritual world. The entire quote reads: *"Le Théâtre de l'Espace concoit une
 dramaturgie a deux plans dont l'un soit le corollaire de l'autre. Au centre un plateau
 rectangulaire ou parvis scènique, est destiné à recevoir le public et à réaliser les
 scènes qui commentent, analysent et rélient l'action publique à l'action universelle,
 en un mot c'est le rappel du corybante dans l'orchestra."* See also Art et action,
 Theatre de l'espace Folio 27.

12 *Il y a ceux qui réussissent et ceux qui échouent. Ceux qui échouent, comme les
 morts par rapport aux vivants sont de beaucoup les plus nombreux. Mais ce sont
 ceux qui échouent qui fertilisent la pensée humaine. Glorifions ceux qui échouent
 et encourageons-les car ce sont eux qui créent la vie. Je repartirai, il repartira, nous
 repartirons, persévérer, persévérer,* « Les Prévisionnaires, » Art et action, *Théâtre
 de l'espace* Folio 27 p. 50.

13 Typescripts for *Les Prévisionnaires* and *Les Métaux* are held in Art et action,
 Théâtre de l'espace Folio 27. Autant's cycle of plays were staged as modest
 performances for a limited audience, not the grand spectacles that he
 and Lara had imagined. Letters in the archive suggest that Autant was
 disappointed by the outcome.

14 Autant and Lara, *La philosophie du théâtre.* Craig wrote repeatedly, "we
 should play in open air" see Craig, *The Theatre—Advancing* p. 19. Meyerhold
 also wrote that theatre should get out into the open air, "we want our setting
 to be an iron pipe or the open sea or something constructed by the new
 man." Meyerhold, *Meyerhold on Theatre* p. 174.

DOI: 10.1057/9781137368683

15 See "Théâtre de L'Espace" in Art et action, *Cinq conceptions de structures dramatiques modernes.*

16 Roann Barris (1998) "Culture as Battleground: Subversive Narratives in Constructivist Architecture and Stage Design," *Journal of Architectural Education,* 52/2 (November 1998), 109–23. See also Cooke, *Russian Avant-Garde: Theories of Art, Architecture and the City* p. 17.

17 Meyerhold, *Meyerhold on Theatre* p. 170.

18 Barris. "Culture as Battleground" p. 111. Vsevelod Meyerhold used such techniques in the early 1920s. See also C. D. Innes (1972) *Irwin Piscador's Political Theatre: The Development of Modern German Drama* (Cambridge: Cambridge University Press).

19 In the context of Soviet Russia, Meyerhold asked how theatre could "imbue spectators with that 'life-giving force' (to quote Comrade Stalin) which will carry the masses forward to a world of new revolutionary creative effort?" In "The Reconstruction of the Theatre" in Meyerhold, *Meyerhold on Theatre* p. 270.

20 In his description of the Théâtre de l'espace, in Cinq conceptions du structures dramatiques modernes, Autant reproduced a plan of Syrkus' renovation of the Irena Solska theatre in Zolibor near Varsovie, Poland. He also showed a photo of Syrkus' set design for "Boston" a drama based on the Sacco and Vanzetti trial. In Poland, Autant and Lara saw a model for a massive "Theatre of the Future" designed in 1929 by Syrkus, Tonecki and Andrzej Pronaszko. Tonecki wrote a short history of environmental theatre in which he cites Apollinaire's poem (quoted above). See Aronson, *The History and Theory of Environmental Scenography* p. 126. Aronson cites Syrkus, Szymon (1973) "On the Simultaneous Theatre" Mysl Teatralna Polskiej Awangardy 1919–1939 (Warsaw). See also Zygmunt Tonecki "Architektura i technika teatralna w inscenizaeji wspolezesnej" *Varsovie* (1935).

21 Szymon Syrkus, *Theatre of the Future or Simultaneous Theatre,* 1928–29.

22 Art et action, "Analyse de la Quintologie des Conceptions de Structures" in Art et action (1952 (1933)) "Le Théâtre universaire," in Art Et Action (ed.), *Cinq conceptions de structures dramatiques modernes* (Paris: Corti). n.p.

23 Art et action, "Cours de comédie spontanée moderne (1e, 2e et 3e année) technique et réalisations," p. 5. Booklets included in Art et action, *Cinq conceptions de structures dramatiques modernes.* In the early 1920s, Meyerhold also developed a gestural form of acting called "biomechanics." See Mikhail Kolesnikov (1991) "The Russian Avant-Garde and the Theatre of the Artist," in Nancy Van Norman Baer (ed.), *Theatre in Revolution* (San Francisco: Thames & Hudson, The Fine Arts Museums of San Francisco), 85–95 p. 90.

24 See: Corvin, *Le Théâtre de recherche entre les deux guerres: Le laboratoire Art et Action.* p.298. In Moscow, Theatre of the Book developed alongside improvisational drama. Autant and Lara wrote "For example, at a certain point in a drama a character, one night, might appear with a bouquet in his

DOI: 10.1057/9781137368683

hand. On another night at the same point, he might have a suitcase or tool or a musical instrument. The audience returned twenty or thirty times to the same play that they knew by heart in order to see the troupe's innovative interpretations." Art et action (1952 (1931) "Le Théâtre du livre," in Art Et Action (ed.), *Cinq conceptions de structures dramatiques modernes* (Paris: Corti) p. 2.

25 Nikolai Pavlovich Okhlopkov as quoted in James Harbeck (1996) "Okhlopkov and the Naissance of the Postmodern," *Theatre Insight*, 7/1. Okhlopkov was a student of Meyerhold in Moscow. He was artistic director of the Realistic Theatre in Moscow from 1930–1937 and developed a type of staging that used many effects from cinema. See also Zygmunt Tonecki (1932) "At the Boundary of Film and Theatre," *Close Up*, 9, pp. 31–35. See also Aronson, *The History and Theory of Environmental Scenography* pp. 239–41.

26 Labrouste's Bibliothéque St. Genevieve in Paris displayed names of authors on its façade, proposing that architecture honestly reveal its interior on its exterior.

27 Claude Autant-Lara and Robert Mallet-Stevens were set designers for *L'Inhumaine* (1923) a film directed by Marcel L'Herbier, who had staged his first play, "Giving Birth to the Dead, Miracle in purple, black and gold" with Autant and Lara in 1919. Claude Autant-Lara designed numerous sets for his parents' productions and became an independent film-maker. See Claude Autant-Lara (1984) *La rage dans le coeur: chronique cinémaographique du 20e siècle* ([Paris]: H. Veyrier).

28 Autant and Lara, *La philosophie du théâtre*, p. 5. He was referring to the broad role of art as an experimental field that seeks truth. He quoted Oscar Wilde, "There are times when art attains the dignity of manual labor."

29 Porte Maillot in 1930, the palace of the Soviets in 1931, and the Chaillot Hill in Paris in 1933.

DOI: 10.1057/9781137368683

3

Artistic Display and Commentary: Theatre of the Book

Abstract: *Autant and Lara's theatre for literary readings separated word and image in multiple spatial layers that defined positions for visual tableaux, readers, commentators, and spectators, all of whom moved spontaneously between layers. Multiple box stages in the theatre design recall medieval "mansions" that held scenes from scripture for spectators who walked and talked among them. The experience of moving between architectural frames, at times performing, then watching others perform, and of perching on the threshold recalls urban life in the many rooms of the city. The Theatre of the Book comments on display spaces in the city and proposes open layers of interactive space in between detached images (like paintings in a museum) and spontaneous conversation, layers essential to a fully engaged society.*

Read, Gray. *Modern Architecture in Theatre: The Experiments of Art et Action*. New York: Palgrave Macmillan, 2014. DOI: 10.1057/9781137368683.

DOI: 10.1057/9781137368683

In 1930, Art et action presented *Le Second Faust (Faust. The Second Part of the Tragedy)*, an interpretation of Wolfgang von Goethe's lesser-known sequel to his epic play, which has a quality of the surreal more than the spiritual.[1] In Autant and Lara's humble theatre, the Grenier Jaune spectators sitting in folding chairs shared the performance. In one scene, Helen of Troy, the ideal of beauty, appeared as a dream invoked from Faust's desires. She was revealed within in a small, raised, and curtained box stage behind the main platform, like an icon in a shrine. Cloaked and silent, she wore a mask of the moon, which could open or close to reveal or conceal her face.[2] An astrologer, who conjured the phantom Helen, straddled the lip of the box stage in a harlequin costume that split her body into black and white, reflecting her role as a medium between worlds. Outside of the tableau on a flanking platform, Faust knelt to adore his own vision like a pilgrim, while Mephistopheles berated him from the other side. Closer and lower, at the same level as the audience, two figures narrated the action. "Proscenia" read Goethe's stage instructions, while "Strophia" read the parts of various minor characters.[3] At points in the play, Faust and Mephistopheles stepped down from the platform to the lectern to read their own lines from Goethe's text. Among the audience, spectators, who probably knew each other, might have made remarks on the side.

According to an Art et action manuscript, Faust, smitten by Helen's beauty, lunged toward her exclaiming, "Here is sure ground! Realities are here." Whereupon the curtain of the inner box stage descended, concealing Helen and draping over the astrologer so only her right (white) side was visible. Proscenia narrated, "Explosion, Faust falls to the ground. The spirits fade into vapor." Mephistopheles carped from the other side, "That's that. To burden oneself with fools, you see, in the end does even the devil injury."[4] Strophia, then added the lines of a pedant commenting on the scene, "reality leads to the absurd."[5]

Spectators could have seen and heard all of these layers of performance, and added their own commentary and discussion off the stage, but within the hall. After the show, they would have descended the precarious stair from Art et action's loft to the street in Montmartre. Back in the city, they might have continued the conversation while walking, shifting their commentary to take in shop window displays, advertising, and other events going on in the multiple rooms that overlook the street, both public and private, framed by curtained windows, which revealed or concealed their minor dramas.

DOI: 10.1057/9781137368683

FIGURE 3.1 *Interior view of the Theatre of the Book (Théâtre du Livre) based on Autant's sketches and model (Damir Sinovcic and author)*

If Art et action's scripts were played within the building that Autant sketched for the Theatre of the Book, they emerge as a wry commentary on the role of architectural framing in presenting images (Figure 3.1). In Paris, shop window displays greeted pedestrians on the streets, while the upper stories of buildings offered fleeting views of people who might appear by chance in ubiquitous balcony windows. Each urban scene, thus framed, is independent yet joined by a web of casual conversation and commentary, such that any coherent story must be assembled from diverse impressions, rather than read directly as a single, continuous narrative. Extending this analogy, Theatre of the Book performances addressed the larger role of images in the city, including those presented by museums, theatres, and cinema—a phantasmagoria that was increasingly integrated into urban life and dependant on the skein of shared cultural knowledge. Architecturally, the building Autant designed for Theatre of the Book performances proposes a series of frames within frames, which specify positions for watching, reading, commentary, and discussion with thresholds in between that heightened the drama of crossing from one to another.

DOI: 10.1057/9781137368683

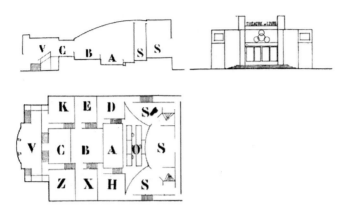

FIGURE 3.2 *Sketches for Theatre of the Book, Edouard Autant (Courtesy: Corti Press)*

Note: Plan shows three raised stages (S) behind lecterns for readers (O), facing an audience in box seats designated for students interested in various aspects of the performance. Section shows levels of stages and seating; Scenes in "mansions" (S); Lecterns (O); Classes in Dramatic Composition (A,D,H); Class in Aesthetics (E); Class in Dramatic Literature (B); Class in Dramatic Technique (X); Class in Comparative Literature (K); Class in Foreign Language (Z); Auditors (C); Vestibule (V).

Theatre of the Book as a theatrical form presented literary readings for scholarly audiences. Autant and Lara specified that the Theatre of the Book focused on works considered too contemplative to be easily produced as plays, yet scenic in conception so they leapt easily into view.[6] They chose literature with "spiritual or metaphysical" themes that evoked vivid visual images through words. Both Autant's sketch for a theatre building and the performances that Art et action presented built on techniques of staging similar to those of the Theatre of Space, yet they defined layered scenes that reached into a deep interior, rather looking outward toward the landscape. The language of the performances was poetic rather than colloquial, and the mood discursive rather than festive. Actors in the inner tableaux were elaborately costumed with robes and masks, appearing as living puppets that interpreted poetic words visually. Framed images, such as Helen of Troy, were strong yet fleeting, like vivid images in the imagination.[7]

In Autant's sketch for the theatre building, a stage with multiple levels and three small box enclosures for separate scenes took one end of the hall facing audience (Figure 3.2). A lectern took a position in front of the stage for readers to narrate the story while multiple tableaux appeared behind them, as if leaping out of the words into view. Autant noted

DOI: 10.1057/9781137368683

that both readers and characters could move from one level to another depending on how directly their speech addressed the audience. At times, a reader might improvise outside the text to interject commentary and jests, like an emcee at a cabaret. Actors in character also might also step out of their roles and out of the frame of the scene to read from the lectern or speak directly to the audience, then return to play their parts. Finally, Autant's sketch for the theatre building shows a series of box seats for spectators grouped into academic classes according to their interests. Seated together they would analyze and discuss the performance. In sum, the arrangement shown in Autant's sketch and his descriptions of performances reveal multiple frames and thresholds that defined calibrated zones in between a purely fictional scene, which is watched, and the purely "real" audience, which watches.

Theatre of literature

Autant and Lara specified that the Theatre of the Book was designed for literature that ventured into both the verbal and visual realms equally, juxtaposing word and image as separate elements.[8] Art et action performed three pieces that they listed as Theatre of the Book: *Le Second Faust*, which proceeds as a series of visions, *Le Tentation de Saint Antoine* (*The Temptation of Saint Antoine*) by Gustave Flaubert, also based on fantastic mental illusions, and an adaptation of *Gargantua et Pantagruel* by Rabelais. The poetic language of all three conjures vivid images, yet simultaneously dwells in the mind as pure lyric verse.

Art et action adapted all three plays to create performances that interpose scenes that can be taken as realistic and scenes that are clearly within a character's memory or imagination. For example, in much of Goethe's play, Faust contemplates his spiritual situation, summoning a rapid series of allegorical or iconic images, such as Helen. He and Mephistopheles step in and out of the scenes while they negotiate and argue with each other. The quick scene changes and visual demands of the imagery make the scenes difficult to stage in a traditional theatre, however they can be well captured in cinema, which has the luxury of camera cuts that can move instantly between shots.[9] On the other hand, the play also has long poetic narratives that are intrinsically theatrical, too weighty for cinema and impossible for the silent films of the 1920s.

DOI: 10.1057/9781137368683

Art et action's performances and Autant's theatre design addressed exactly this intersection between speech and image that was topical in contemporary discussions of cinema.

They found a model in the nascent Soviet Union, where theatre troupes performed readings and enactments of classic Russian literature to promote cultural unity among a vast uneducated population. Performances were intended to fill a role that the church had long played in constructing a shared culture for the masses. The reality of Soviet literary theatre, however, was somewhat less compelling. In a memoir of their visit in 1928, Lara describes searching Moscow in a driving rain for a literary theatre performance. She and Autant eventually found it tucked in the upper floor of a dimly lit warehouse. When they were finally ushered into the performance hall, they found more actors than spectators in the room. Throughout the reading, the lights never changed. Readers sat on white cubes, speaking multiple parts in rhythmic alternation or in unison, while actors dressed in simple red and black played the scenes in expressive gestures and motions. The cubes, as the only décor, were rearranged to suggest various settings. Autant and Lara stayed through four performances of one hour each and emerged with "a sense of pure joy, like the relief one feels seeing a diver reappear after being under water for too long."[10] Lara wrote that the readings released the delicate spiritual qualities of written works that normally remained submerged beneath the immediacy of theatrical performance. She explained that when dialogue is read, word and action are separated, allowing the poetry to emerge more clearly. A gap between hearing and seeing lets the words dwell for a moment before they are interpreted as normal, integrated action.

In Paris, such literary theatre had not been developed as a genre, however cinema offered a parallel form. Popular and classic novels were often adapted as silent films in serial segments. Every week one chapter of a book would appear in a journal and the corresponding film would be shown in the theatre so readers/viewers could read the story and then follow the film visually with minimal breaks for text.[11] Readers could engage the spiritual and intellectual parts of the story directly in reading the author's words, then see the action come to life on the screen. These *ciné-romans* (cinema novels) kept people coming back to the cinema every week and supported a popular literary culture.

DOI: 10.1057/9781137368683

The design of Theatre of the Book

For the several pieces that Autant and Lara designated as Theatre of the Book and performed in the Grenier Jaune, they configured the stage in multiple layers. For example, the set of *Le Tentation de Saint Antoine* had four distinct areas for scenes at various levels and two lecterns flanking them (Figure 3.3). The readers, identified as "Proscenia" and "Glossa," set the scene and maintained a running commentary. "Proscenia," meaning "in front of the scene," wore ear mufflers and read poetic descriptions of the visual part of the scene. In words, she evoked visual atmospheric qualities that were not represented in the set. "Glossa" refers to a gloss or interpretation of a text, one classically written in the margins of a book by readers.[12] She wore a blindfold and chanted verses with an ethereal tone to emphasize their poetic meaning, like a blind Tiresias who saw deeply into time. These figures added two layers of commentary, the former identified with the visual theatric setting in the immediate present, and the latter with literary interpretation in historical depth.

The play proceeded as a series of visions that tempted the hermit Saint Antoine who was confined to a sunken central stage, where he was visible only from the waist up. On raised platforms behind him, heroic figures such as the Queen of Sheba and the ascetic Saint Hilarion

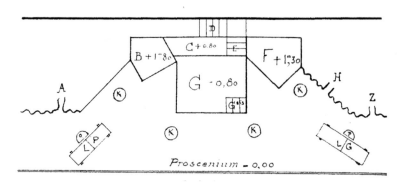

FIGURE 3.3 *Stage design for Le tentation de Saint Antoine, 1930 (Courtesy Corti Press)*

Note: Entry for prologue and Proscenia (A); Stage for Hilarion (B); Stage for Apollonius (C); Entry for the Queen of Sheba (D); Stage for the Queen of Sheba (E); Stage for Damis (F); Pit of St. Antoine (G); Seat of St. Antoine (Gbis); Entry for the old Ebionite (H); Entry for Medusa and Glossa (Z); Seat for Glossa (P); Lectern for Glossa (LG); Lighting (K); Lectern of Proscenia (LP); Seat of Proscenia (O).

DOI: 10.1057/9781137368683

appeared wearing draped robes that made them seem to hover in space. Each figure stood at a distinct height above the stage, which identified them as character, reader, or commentator.

Autant's sketch for a building for Theatre of the Book performances shows a similar set of layers in calibrated degrees of distance. A long lectern for several readers faces the audience in front of three raised box stages framed architecturally to designate that the realm of the visual imagery was distinct from the realm outside[13] (Image link: http://figshare.com/articles/3_5section_14Aug_tif/771965). The two flanking box stages are labeled as venues for interior and exterior scenes respectively, whereas the central stage was reserved for abstract tableaux that illustrated the symbolic meaning of the text. The audience saw into the box stages as if they were looking into rooms with a wall removed or in this case, as if looking into a building that had been cut in section to reveal adjacent apartments. The central stage, in particular, was raised above the flanking scenes and framed with a square proscenium arch so it was doubly distanced from the audience and would seem to float independently as an aedicule for a tableau or icon. In the Faust example, Helen Queen of Troy, wearing a mask of the moon, merged classical and cosmological references into a single, resonant image (see Figure 3.1). The presentation of characters as symbols recalled a Renaissance tradition of iconographic art and poetry that had been revived by their mentor Guillaume Apollinaire, who studied Renaissance Hermeticism and occult beliefs that attributed specific power to images.[14]

Whereas the lecterns and multiple stages define degrees of theatrical distance the audience seating was designed for collegial discussion. In plan each group or class is given a box to itself with a distinct view of the performance. Autant's sketch places classes in dramatic composition closest to the stages so students could see actors' motions and demeanor in detail. Presumably, these students could also step up to stage to read or play roles. Behind them and raised slightly, classes in aesthetics, dramatic literature, and dramatic technique could listen to the text being read and see all three stages easily. Located in the back of the room were classes in comparative literature and foreign languages, which focused on listening to the words, more than watching the scenes.

Each area would allow a class to arrange tables and chairs so students could face each other to discuss the particular aspect of the performance that brought them together, adding their opinions and interpretations. The classes and the box seating recall the Russian theatre's educational

DOI: 10.1057/9781137368683

mission and gesture toward the role of theatre as a source of shared literary culture. Indeed, such a culture takes shape in the comments and discussions among scholars and audiences as well as in the literature itself.

The entire hall of the Theatre of the Book was enclosed without windows so had no visual contact with the city or sky. However, the commentary from the lecterns interspersed with the text and the discussion among students in academic classes opened the performance to analysis. References to the outside were literary rather than visual. The various classes effectively dissected performances into artistic elements: dramatic composition, literature, and language. In Art et action's manuscripts of Theatre of the Book performances, a panoply of images and characters from a broad literary landscape popped up as independent voices, for example Polichinelle, Oberon, and Titania, who would have been familiar to spectators. Discussions among the class groups would presumably have teased out literary allusions and added to them. This academic window out from the performance to a larger field of ideas released it into a realm of the mind as effectively as the skylights in the Theatre of Space linked performances with the physical cosmos.

Performances in the Theatre of the Book explored theatric distance, a distinction between here and there or between real and fictional worlds created by a proscenium arch or picture frame. In Western traditions of art, figures inside a frame appear unselfconsciously in their other world, while those outside the frame watch. In the Theatre of the Book, Art et action elaborated a series of frames and boundaries through both architecture and performance to define positions in between the hermetic other world of a scene and the position of the audience as spectators watching from the outside. They open the space of the frame to examine the mechanism by which a scene can be transformed into a story that is simultaneously present and elsewhere. Then they invite actors and spectators to balance on the threshold, where they might talk about it in words and actions that are already part of the performance. By distinguishing degrees of distance, they could mix "reality" and "fiction," throwing both into question.

Mansions and windows

The three box stages, which enshrined scenes as tableaux, drew on a medieval tradition of liturgical drama that developed out of the

DOI: 10.1057/9781137368683

performance of high mass. By the twelfth century, mystery plays and dramas of the passion were presented as a sequence of scenes presented first in the chapels of the church, then in separate small enclosures called "mansions" that were set up in the church plaza on festival days[15] (Image link: http://visualiseur.bnf.fr/Visualiseur?Destination=Daguer re&O=7906169&E=JPEG&NavigationSimplifiee=ok&typeFonds=noi r). In performances, each mansion offered a skit, which was repeated over and over so that parishioners could move from one to the next in sequence as if moving along Stations of the Cross. Performances sometimes lasted several days, with each mansion hosting a new scene each day. A well-documented 1501 production of "The Mystery of the Passion" in the town of Mons had 67 scenes, took 48 days in rehearsal and four days in performance.[16] The Mons production included mechanical animals, trap doors, and a pool of water with a small boat to show Jesus as a fisherman in the Sea of Galilee. From year to year such productions became more and more elaborate, until some clergy complained that depictions of the devil had become so flamboyantly comical that they were not appropriate in the church.

In large productions outside in the town square, mansions were built with roofs to protect scenery from rain, and sometimes wheels so they could travel from town to town. Liturgical performances transformed market squares, replacing the stalls of merchants and the spontaneous theatre of the market with mansions that opened views into heaven and hell to teach the stories of a common culture.

The form of the mansion as an aedicula or small house, which framed a person or scene, was adopted by popular theatre, but also by galleries, which displayed paintings and precious objects for contemplation within elaborate frames. In the twentieth century, modern artists rejected the picture frame, arguing that paintings should act in the space of the viewer rather than retreating into another world on the other side of a framed view-window. They should act in this world.

Modern architects also rejected the traditional framed window in favor of openings defined as voids in composition with areas of solid wall. This shift in approach emerged in a noted architectural debate between Le Corbusier and Auguste Perret that addressed how buildings stage the theatre of the city.

Le Corbusier promoted a frameless horizontal window that offered a panoramic view of the landscape to those inside. In 1923, Perret

DOI: 10.1057/9781137368683

responded, arguing in favor of the vertical French window that frames a human figure, "in accord with his silhouette."[17] Pointedly, Le Corbusier described a view from the inside while Perret consistently indicated a view from the outside. The silhouette is that of someone inside a room seen by someone in the street outside, specifically a silhouette cast onto a sheer curtain at night that appears as the person inside comes close to the window (in full knowledge that his or her shadow is visible from the outside).[18] For Perret, a critical function of a window is to address an audience in the street and the city at large, so someone inside might choose to approach the opening to become visible and engage the city, or step back into the interior and disappear from view. Windows frame people, transforming normal inhabitation into potential theatre and heightening urban life with the casual thrill of possible connection. Both Perret and Autant designed apartment houses in Paris in a well-established tradition that presented the street with a series of inhabited windows (Figure 3.4).

Each opened into a room and took a position with other windows opening into other rooms across a façade. Every room contained a domestic scene enacted by a family as they went about their lives and

FIGURE 3.4 *Windows in houses designed by Edouard Autant and Auguste Perret*

Note: A. House designed by Edouard Autant in 1905, Rue Abbeville, Paris; B. House designed by Auguste Perret in 1902–4, Rue Franklin, Paris.

DOI: 10.1057/9781137368683

each offered the possibility that someone might step out and engage passersby directly with a wave or a word.

Cinematic theatre, cinematic city

In a design for a theatre for the 1925 Exposition of Decorative Arts, Perret framed the stage in three sections, one deep central stage and two shallow flanking platforms separated by columns.

Perret wrote that multiple stages could speed up the action in the theatre by allowing rapid scene changes and simultaneous action, giving performances a quality closer to cinema than any other form of live theatre. Later Perret expressed his disappointment that none of the actual performances in his theatre took advantage of the dramatic possibilities of the space. He wrote, "I tried the triple scene, it was not emulated, no one understood. But I remain convinced that it is one of the most effective ways that theater can compete with cinema."[19]

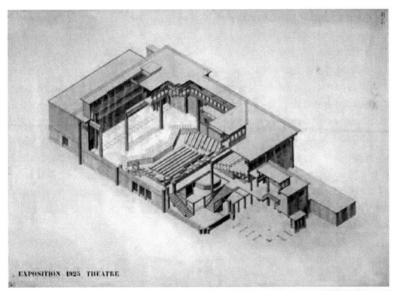

FIGURE 3.5 *Auguste Perret, Theatre for the 1925 Exposition of Decorative Arts (Art © Estate of Auguste Perret/SAIF, Paris/VAGA, New York)*

DOI: 10.1057/9781137368683

The techniques and effects of montage in cinema were a lively topic of discussion throughout the 1920s in artistic circles and in the press. In silent cinema, montage was one of most powerful artistic means to express a narrative of interconnected events or a character's inner thoughts. Director Sergei Eisenstein, who trained as an architect and had worked with Vsevelod Meyerhold in Moscow, considered montage the nerve of cinema, one of its most effective means of storytelling.

Returning to Perret's differences with Le Corbusier, the issue of vertical versus horizontal windows emerges as a disagreement over the kind of performance buildings in the city could or should present—scenes in motion or independent shots in montage. Both were modern and cinematic but their implications for urban life differed. Le Corbusier's strip window offered spectators inside the building a panoramic view similar to a long pan or tracking shot, as if the city were a landscape seen through the window of a car in motion. For spectators outside in the city, his horizontal windows in buildings such as the Villa Roche offer a glimpse only into entry halls and corridors where someone might appear walking, but never at rest, nor returning a gaze. Through its windows, Le Corbusier's buildings presented urban life as an action film—long on visual excitement but short on plot. On the other hand, Perret's architectural cinema might be compared to a mystery or a soap opera—an intricate drama. His vertical windows presented inhabitants a view to the outside framed as a picture with foreground, middle ground, and background, so they might understand the full scene, stretching into spatial depth. To passersby, tall windows framed interior scenes that have depth, yet become more obscure as the view recedes, such that only someone who approached very close to the window (perhaps to look out) would be visible. Several of these window scenes juxtaposed in a building façade present passersby with a spontaneous montage as they shift their gaze from one window to another and imagine connections between them. The similarity between urban windows and cinematic montage was played skillfully by Alfred Hitchcock in *Rear Window*.

In the 1920s, the cinematic framing of urban life was explored with some precision by architect Robert Mallet-Stevens, who designed sets for cinema, at the same time as he designed apartment buildings and shops for Paris. Mallet-Stevens was loosely associated with the same circle of artists as Autant, Lara, and Perret, having designed sets for films directed by their friend and colleague, Marcel L'Herbier.[20] In 1929,

DOI: 10.1057/9781137368683

Mallet-Stevens published a treatise on set design for cinema that outlined techniques to situate the quick glimpse of the camera.[21] In short, he wrote that sets should be simple, geometric, and shallow. Plain box forms and crisp shadows can establish depth in a glance, even if the shadows have to be painted. Vertical and horizontal lines contrast the movement of a figure to make it more dynamic. Flat walls can receive silhouettes and shadows to double the figures, creating rhythm and suspense.

Mallet-Stevens used the same techniques in architectural design. For example a series of houses that he completed in 1926 have freestanding elements that frame views in and out[22] (Image link: http://commons.wikimedia.org/wiki/File:Rue_mallet-stevens_02.JPG). The framing devices focus views out from terraces, so residents see the city as a picture. They also frame views from the street, so someone walking by might see a figure at the terrace railing as if in a window with the sky (or terrace plants) as a background. If the figure returns the gaze, then the full reciprocal relationship of theatre comes into play. The one watching and the one being watched both perform for each other.[23] Mallet-Stevens designed his own house within the row as a setting for fashion photography. It appeared in numerous publications and several movies.[24]

Each of the urban buildings designed by Perret, Le Corbusier, and Mallet-Stevens explicitly stage the casual performances that contribute to the character of their streets, and their city. All considered themselves modern. Their differences of opinion concerned *mise-en-scène*.

Double city

In Paris of the 1920s, the question of architectural framing and theatrical distance was particularly pointed. In form, the three stages of the Theatre of the Book resembled the shop windows that increasingly lined commercial boulevards in Paris.[25] Shop windows were literally small stages that presented mannequins as actors in attitudes and clothing that often referred to popular theatre and cinema.[26] They were seen one after another as one walked past, presenting a series of persona, in relation to which a woman might construct a public presentation of herself. Skillful window-shoppers kept up with fashion imagery in magazines and advertising and took a critical stance in discussions of fashion and in each choice of dress.[27]

DOI: 10.1057/9781137368683

The shops of Paris had long been a fashion gallery duly loved and despised by its artists. In the nineteenth century, poet Charles Baudelaire and novelist Honore Balzac described the sirens of the boutiques as honorary citizens whose enticements gave the city charm and made its streets habitable. In the mid-1920s, Mallet-Stevens and designer René Herbst published a series of books promoting shop fronts as a form of architectural art, a "décor of the street," writing "the dancer and the shopkeeper have given us a new age of air, light and joy."[28] They designed both windows and displays that played on the boundary between passersby outside the window and mannequins within, suggesting that a woman outside might, with a purchase, assume the attributes of the mannequin and become like an actress.[29] In displays for Siegel, a manufacturer of mannequins, Herbst placed three identical figures in identical dresses on steps that descended to the sidewalk. As pedestrians walked by the window, their point of view changed so the figures appeared to separate into a sequence. The mannequins stepped down toward the sidewalk so a shopper outside the glass took a position as the next in line. Inside the store, mannequins were arranged casually on a wide set of steps that led up to dressing rooms. When a woman tried on a dress, she would emerge among them, as if on stage.

In 1924, Mallet-Stevens organized an installation at the annual Salon d'Automne that presented a public square surrounded by ten shop window displays, each designed by a different architect. Each shop posed a distinct spatial relationship between passersby and the goods on display. For example, Herbst placed mannequins on a stage behind a rippling glass wall that drew window-shoppers around and among the figures. Pierre Chareau designed a vertical display of fabrics that rose over the heads of onlookers so they were surrounded on all sides by color and pattern.

Autant and Lara explored the same issues of framing and multiple scenes in the performances and design of the Theatre of the Book. To the architectural debate they contributed the image of Helen illuminated by the centuries of gloss and open to on-going discussion. Theatre of the Book can be read as a challenge to architects to open the visual frame into depth to create positions for commentary and discussion at a series of thresholds in between the unreachable ideals of a pure object of vision and the purely subjective spectator. Theatre of the Book performances commented on the many framed views in the city and the conversations

DOI: 10.1057/9781137368683

they sparked, whether performed explicitly or generated spontaneously as one walks the streets and talks with friends.

Notes

1 Art et action, "Le Second Faust," p. 20 in Art et action, "Le Théâtre du livre."
2 The moon mask had a moveable hoop operated by a string, which could open or close it, and an interior light to illuminate the actor's face.
3 The character "Proscenia" derives her name from proscenium, in front of the stage. "Strophia" refers to a turn of the Greek chorus, from which a poetic strophe was derived. The chorus traditionally mediated between actors and audience, setting the scene or commenting on the action.
4 I use the English translation of Goethe's text by Louis MacNeice, Wolfgang von Goethe (1951) *Goethe's Faust*, trans. Louis Macneice (NY: Oxford University Press) p. 190.
5 Here I translate from Art et action's text since it differs from other translations of Goethe's words.
6 Art et action, "Le Théâtre du livre," p. 1. This book contains Autant's sketches for a theatre building, descriptions of performances and texts of plays designated as Theatre of the Book. The book was later published as a section of Art et action, *Cinq conceptions de structures dramatiques modernes*.
7 Art et action, "Le Théâtre du livre" includes texts, sketches of stage layout, stage directions and photos of performance for three plays performed at their home stage in Montmartre *Le Tentation de Saint Antoine* by Flaubert, *Le Second Faust* by Goethe and *Gargantua*, adapted from *Gargantua and Pantagruel* by Rabelais.
8 Art et action, "Le Théâtre du livre," p. 9.
9 Sergei Eisenstein (1949) *Film Form*, trans. Jay Leyda (NY: Harcourt) p. 12 credits Flaubert with inventing montage in his novel, *Madame Bovary*, by interlacing fragments of two conversations so they interacted at another level.
10 Art et action, "Le Théâtre du livre." See non-paginated section at beginning of booklet. See also: Lara, *L'Art dramatique russe in 1928* p. 20.
11 Richard Abel (1988) *French Film Theory and Criticism: 1907–1939* (Princeton: Princeton University Press) p. 96. discusses ciné-roman as a genre.
12 "Le Tentation de St Antoine" in Art et action, "Le Théâtre du livre."
13 See: Cross-section of Theatre of the Book.
14 See Hicken, *Apollinaire, Cubism and Orphism* p. 55.
15 See: Valenciennes Passion Play Mansions, 1547.
16 Kenneth MacGowan (1955) *The Living Stage* (NY: Prentice Hall) p. 63.
17 Auguste Perret "Les besoins collectifs et l'architecture," *Encyclopédie Française* (XVI, Paris), Section 68, page 7. See also Britton, *Auguste Perret* p. 135. and

DOI: 10.1057/9781137368683

Bruon Reichlin (1984) "The Pros and Cons of the Horizontal Windows: The Perret-Le Corbusier Debate," *Daidalos*, 13, 64–78.

18 Urban literature is replete with stories of peeping Toms who see what they shouldn't see and wanton women who show what they shouldn't show through the windows of the city. However, the windows of most parlors in Paris and other cities open onto the street or a common courtyard so passersby have a view limited by curtains and the angle of view. When inside a room, one approaches the window aware of the possibility of being seen with the social and dramatic potential that implies. Sitting in a front window in Philadelphia, I got to know everyone who habitually walked by.

19 Perret, "Le Théâtre."

20 In 1919, Art et action performed L'Herbier's play, *L'Enfantement du mort* (The Birth of Death). Mallet-Stevens designed sets for L'Herbier's *L'Inhumaine* (1924) and *Vertige* (1926). Other sets for scenes in L'Inhumaine were designed by painter Fernand Léger and Claude Autant-Lara, son of Edouard Autant and Louise Lara who designed many sets and costumes for Art et action. Studies of Mallet-Steven's work include Jean-François Pinchon (ed.), (1990) *Rob. Mallet-Stevens: Architecture, Furniture, Interior Design* (Cambridge, MA: MIT Press).and Richard Becherer (2000) "Picturing architecture otherwise: the voguing of the Maison Mallet-Stevens," *Art history*, 23/4 (2000 Nov.), 559–98.

21 Robert Mallet-Stevens (1929b) "Le dècor moderne du cinema," *L'Art cinématographique*, 6.

22 Robert Mallet-Stevens, Apartment building on Rue Mallet-Stevens, 1926, showing frames surrounding roof terraces.

23 Yhcam (1912) "Cinématographie," *Ciné-Journal*, 191, 36–41. Reprinted in Abel, *French Film Theory and Criticism: 1907–1939* p. 72.

24 On Robert Mallet-Stevens relationship with film, photography and fashion see Becherer, "Picturing architecture otherwise: the voguing of the Maison Mallet-Stevens." The Maison Mallet-Stevens was used in Greta Garbo's 1929 film The Kiss, a French commercial feature *La Sirène des Tropiques,* and a Jacques Feyder film *Les Nouveaux messieurs* (1928). See Becherer, "Picturing architecture otherwise: the voguing of the Maison Mallet-Stevens," p. 563.

25 The Prefect of the Seine (the position occupied by Baron von Haussmann) explicitly sought to "modernize" building façades as a spectacle of fashion that would attract shoppers from abroad. See Gronberg, *Designs on Modernity*; for a thoughtful analysis of Paris boutiques and the images of the 1925 Exposition, particularly chapter 3, "La Boutique and the face of modern Paris" p. 53ff.

26 Standish Lawder (1975) *The Cubist Cinema* (NY: New York University Press) pp. 94–95 & 161.

DOI: 10.1057/9781137368683

27 Gronberg, *Designs on Modernity*. Gronberg develops the fundamental
 theatricality of fashion display and shopping in Paris, "the woman's city," p. 31
 She also notes that shopping was an act of *toilette* or putting oneself together.
 Each shop specialized in clothing, hats, make up, or jewelry for part of the
 body so a woman had to shop extensively to assemble a complete fashion
 identity. p. 43. Shopping streets were explicitly likened to cinema, p. 67.
28 Robert Mallet-Stevens (ed.) (1929a) *Le Décor de la rue, les magasins, les
 étalages, les stands d'exposition, les éclairages*, 2nd Series (Paris: Editions
 Parade) p. 4. Herbst and Mallet-Stevens edited a series of publications on
 modern shop facades and displays for Parade magazine. Herbst, *Devantures et
 Installations de Magasins*. Rene Herbst (1927) *Nouvelles devantures et magazines
 parisian* (Paris: Moreau). Herbst, *Boutiques et magasins*. Herbst and Mallet-
 Stevens, *Présentation, 2e série: Le décor de la rue, les magasins, les étalages, les
 stands d'exposition, les éclairages*. Herbst, *Nouvelles devantures et Magasins;
 agencements de parisiens*.
29 There is extensive literature on mannequins, shopping, and the manipulation
 of the female body in fashion. See Stella Bruzzi and Pamela Church Gibson
 (eds) (2000) *Fashion Cultures: Theories, Explorations, and Analysis* (London:
 Routledge).

DOI: 10.1057/9781137368683

4
The Spectator and Mass Media: Chamber Theatre

Abstract: *Art et action's largest, yet most intimate theatre commented upon the role of the spectator in modern mass culture. Autant's spatial design isolates each spectator in a box seat so he or she might focus on the scene with vicarious intensity, as if alone. However, the theatre is sky-lit, so each spectator would see a crowd of others in the opposite bank of seats. Inserted into the city, Chamber Theatre performances invoke a characteristically modern paradox of being alone yet together. Plays that Autant and Lara performed present archetypal characters who are seen only as shadows or who communicate across a barrier, heard but not seen. This staging invokes the new channels of media within the purview of architecture and abstracted them as elements of myth.*

Read, Gray. *Modern Architecture in Theatre: The Experiments of Art et Action.* New York: Palgrave Macmillan, 2014. DOI: 10.1057/9781137368683.

DOI: 10.1057/9781137368683

The dreamspace of theatre and cinema speaks to the inner imagination of each person who watches, even among a mass audience of others who also watch. In the intense act of creative watching, one can hear the stories personally as they resonate in memory, even as a multitude of others also hears the same stories resonate, each in his or her own personal way. Alone yet together we participate in the stories of modern collective culture (Figure 4.1). In Chamber Theatre performances, Art et action explored the act of watching within a modern mass culture, seeking to "express the permanence of the most profound human sentiments."

In 1931 Autant and Lara examined the act of watching in a presentation of *Ecce Homo*, a story by Max Deauville that follows several indolent observers of the crucifixion (Figure 4.2).[1] In one scene, a wealthy man and his son stand on a balcony in Jerusalem, overlooking a crowd gathered to watch Pontius Pilot deliver his decision. In Art et action's performance the actors gazed out from the stage to survey the real audience of the play, thereby casting the audience as the crowd within the story, watching Pontius Pilot.

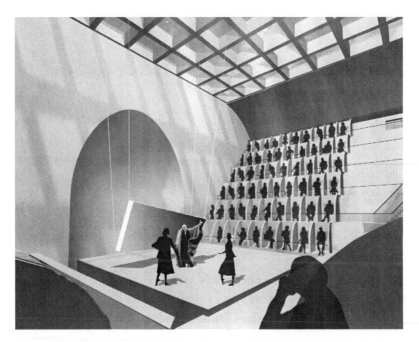

FIGURE 4.1 *Interior view of Chamber Theatre (Théâtre de Chambre), based on sketches by Edouard Autant, 1932 (Damir Sinovcic and author)*

DOI: 10.1057/9781137368683

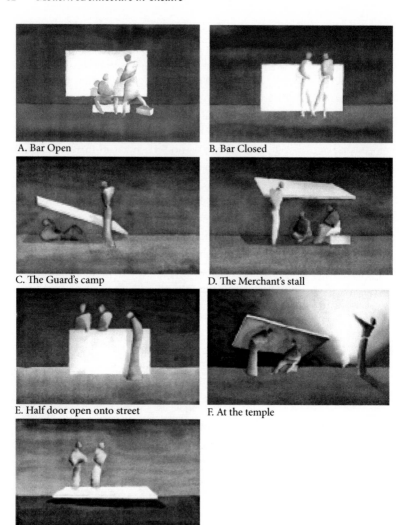

A. Bar Open

B. Bar Closed

C. The Guard's camp

D. The Merchant's stall

E. Half door open onto street

F. At the temple

G. Terrace overlooking the City

FIGURE 4.2 *Seven scenes from* Ecce Homo *performed by Art et action, 1931 (Image by author based on archival photos)*

The actors' gaze returned that of the spectators, crossing the boundary of narrative to elevate the act of watching into view.

Each of the seven scenes in the play as presented by Art et action addressed an aspect of the act of watching. Each scene was defined spatially by the position of a large flat panel, which was raised, turned, and tilted by adjusting four counterweighted white cords at its corners.

DOI: 10.1057/9781137368683

In the balcony scene, the rich man holds a position behind the panel and separated from the audience, a stance that reinforced his arrogant distance from the people he surveys. As the scene progressed, the son rejects his father's point of view and exits to reappear in front of the panel, downstage, leaving his father aloof and alone. Redefining himself, the son takes a new position as part of the crowd of spectators, where he engages both the fictive city and the real audience.

In another scene, the panel was positioned low and at an angle to represent a merchant's stall. Two market sellers crouch beneath it, while others walk by, without looking down. A frightened stranger asks for shelter and tells his story. The merchants conceal him from policing soldiers. In the shadowy shelter of the panel, they bend to share an intimate conversation, which was heard by the audience, yet was unnoticed by passersby on stage. The spectators watched and listened, even as characters in the story did not.

Members of Art et action's audience might also have perceived the political contrast embedded in the two scenes. The wealthy man standing upright in bright light above the panel was portrayed as distant and suspect, whereas the huddled market sellers were sympathetic in their shadowy space. The panel participated in the action, dividing the stage into contrasting areas of light and dark, high and low, near and far to give actors positions that defined their roles. It acted also to give spectators a position in relation to the characters so that they could assume their roles in the narrative events. As a spatial scheme that spanned all seven scenes, the bright surface was a constant presence that shaped the story, a presence that Art et action identified as spiritual.

In their fourth genre of theatre, Art et action presented introspective dramas with the tone of inner dialogue that derived from symbolist drama, while exploring the modern act of watching. In both set and theatre design they cast the spectator as an active participant who remakes all that is watched as an internal narrative in memory: "It is here that we disentangle our most profound individual qualities in order to better cultivate them."[2] In contrast to the festival-like performances of the Theatre of Space, or the tableaux and commentary of the Theatre of the Book, Autant and Lara defined Chamber Theatre as intimate dramas played on a single stage, which spectators witnessed with silent intensity. Chamber Theatre explored emotional rather than intellectual themes, individual rather than collective experience, and relied on spoken drama rather than music, poetry, or visual tableaux. Chamber Theatre performances

DOI: 10.1057/9781137368683

conflated time, mixing past and present in what Autant and Lara called "achronic" drama, like memory images that compress disparate events together. In *Ecce Homo*, for example, unrest in Galilee was called "communist trouble" and one character wore a turban and smoking jacket.

The most explicit model for Art et action's experiments in set design was Soviet director Alexander Tairov's Chamber Theatre. Tairov shared Autant's symbolist leanings as well as a commitment to classical plays such as "Phedre" and "Antigone" interpreted with an emphasis on expressive movement. In 1923, at the Theatre des Champs-Elysées in Paris, Tairov's troupe presented an athletic *Giroflé Girofla* with a constructivist set designed by Georgii Yakulov.[3] Amidst scaffolding, ladders, suspended platforms, and firemen's poles, actors climbed and swung against a white background that revealed every motion of their dark-costumed bodies[4] (Image link: http://digitalcollections.nypl.org/items/9b63192d-fc98-c7d8-e040-e00a18065e11). In choreographed drama, they occupied the full three dimensions of the set to give physical expression to the story. Tairov wrote that the set should be integrated with the movement of actors to create a single, rhythmic impression as one "organic composition."[5] He wrote that in scenes of particular stress, the set should present a physical obstacle or barrier that resists an actor's movement, setting up conditions of struggle, which spectators would feel empathetically in their own bodies.[6]

Tairov built on the ideas of Edward Gordon Craig in expressing dramatic tension physically in sets that offered actors spatial opposites—high/low, near/far, enclosed/open—which they might exploit in their gestures and movements.[7] In 1911 Craig advised that a set designer should begin work by imagining the principal tension of a scene as pure movement stripped of all setting and words, in other words, free of any figural indication of place or time.[8] The designer must give actors the most extreme spatial contrast that the stage will allow, so they can tell the story through movement in real space.

Chamber Theatre building

For spatial sets and performances of Chamber Theatre, Autant designed a theatre-in-the-round, like a small arena, in which the audience sat in sharply banked rows on three sides of a single stage (Figure 4.3).

The scheme places each spectator in an individual box seat separated from his or her neighbors by screen partitions. Seven levels of box seats

DOI: 10.1057/9781137368683

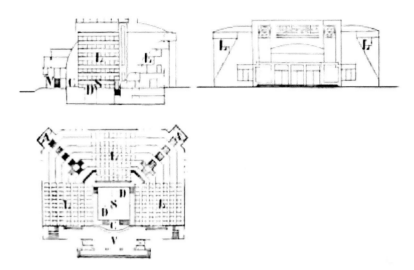

FIGURE 4.3 *Chamber Theatre sketches by Autant (Courtesy: Corti Press)*

Note: Plan shows central stage (S) surrounded by seating for spectators in individual box seats separated from their neighbors by a screen. Section shows seating banked so steeply that spectators would not see others below or above them. Seats are accessed from behind. Section also shows sunken passage around the stage and skylights above. Key: Parabolic curve (C) for sound; Scenery (D); Individual box seats for spectators (L); Stage (S); Entry Hall (V).

are stacked, so spectators would see no one in front of, beside, or behind them, isolating them from all distraction. Yet they were neither alone nor in the dark. The sketch shows skylights above the stage, so the entire space would be lit uniformly, enabling spectators to look across the hall to see others in the audience at a distance. Autant wrote that spectators would feel "alone yet sustained by the impersonality of a large group."[9]

From their perch, spectators would look slightly down on a stage to see actors moving spatially in the round. The stage is separated from the audience seating by a sunken walkway with stairways up to the platform, so the actors would appear to rise up from below rather than enter from the wings as in a traditional theatre. On the fourth side of the stage, Autant drew an apse-like sounding board that would amplify actors' voices. In a description of the theatre, he noted that reflected sound would seem detached from view and closer than might be expected, giving a sense of intimacy.

The spectators' experience of solitary immersion in a detached narrative bears relationship with cinema, while the theatre-in-the-round

DOI: 10.1057/9781137368683

arrangement belongs to live performance or spectacle. The open daylight and steeply banked seating suggests an arena, in which masses of people watch sporting contests and cheer their team. This odd mix of theatric forms proposes an experience that is simultaneously sheltered and exposed, isolated and shared. From a cloistered individual seat one would watch the play, while clearly seeing the audience on the other side of the stage as they also watch, and at the same time be aware that one's own act of watching is on display amidst a mass of unseen neighbors. In this scenario, seeing and being seen are not reciprocal. The act of watching is solitary, with vivid, personal focus, and yet one is observed as simply a face in the crowd, among a multitude of others.

Autant and Lara's Chamber Theatre performances seem to point out the pathos of the anonymous spectator in modern society and to propose a more heroic position for those who watch alone but together. In their scenario, the observer is pointedly not invisible: he or she does not sit in a darkened theatre or retreat behind a screen to watch undetected, nor hold a position of power over the bodies being seen. The observer is fully visible and fully present. He or she can be seen by the actors and by other spectators, if at a distance, so is counted as present in the crowd. In this position among others, the observer is pointedly not a disinterested *flaneur* spending only half attention on the scene at hand; rather he or she fully engaged as one who watches.

The set as a third player

In performances such as *Ecce Homo*, Art et action designed the set as an active character, which performed a role similar to that of the chorus in Greek drama. Traditionally, the chorus held a position in between actors and audience. It anchored the scene, set the mood or rhythm of the play, and established the moral structure in which the action took place. The third actor often revealed for the audience a moral or divine structure that the characters did not see. Autant's associate, the theorist Georges Polti, wrote that Sophocles interpreted the chorus as a third, all-knowing actor, which either set up a situation that ensnared two people in a charged relationship, or resolved the plot's tension as a rescuer or *deus ex machina*.[10] Many modern theatre directors experimented with reviving the chorus or some such intermediary that spoke directly to the audience and acted in the play as their surrogate.[11] In Art et action's dramas, the

DOI: 10.1057/9781137368683

abstracted architecture of the set can be understood as this third actor, who presented an overarching, omniscient structure, a plot or plan that establishes the rules of play and defines the position of the audience.

This is the traditional role of architecture. Much has been written on the hegemonic power of buildings built by kings and conquerors to legitimate their rule. In the 1920s, cultural critic Georges Bataille railed against cathedrals, arguing that architecture itself is oppressive: its structure, proportion, and even its logic enforces order from above. He wrote, "it is in the form of cathedral or palace that Church or State speaks to the multitudes and imposes silence upon them."[12] Bataille charged that the primary job of architecture was to stop the advancement of time, wrapping it in the somber shroud of an existing hierarchy that denies growth, change, and life itself. Recent historical studies interpret buildings as instruments of rhetoric or coercion tuned to the specific aims of their creators, while others document how a building's actions can be appropriated or inverted.[13]

In modern theatre such as Autant and Lara's, the sets act with the hegemonic power of architecture, like the third player. And some held a sharp political message. Soviet director Vslevolod Meyerhold and set designer Liubov Popova, for example, staged *The Magnanimous Cuckold* in 1922, the story of a foolish husband who tried to demonstrate his wife's faithfulness by prostituting her to the men of the village. Popova built a scaffold structure with ramps, ladders, and a monumental wheel, through which the actors tumbled with expressive, heroic gestures[14] (Image link: http://www.glopad.org/pi/en/image/914). The abstract set did not portray the literal locales of the story, but spoke to the audience in visual metaphors, proposing a sexual image of industrial appetite. Village men were both seduced and ravaged by the machine to become the dauntless workers of the contemporary Soviet Union.[15] The frenetic action of the play filled the scaffolding with men who moved with the virile strength of traditional Russian dancers while becoming grist for the female/industrial machine. The set acted as a third player to drive the drama, making references both inside and outside the play, some of which criticized the same Soviet project that Meyerhold vocally supported.

In Paris, Autant and Lara followed developments in revolutionary Soviet theatre closely. Consistent with their hopes for the future, Autant's set design experiments explicitly rejected traditional hierarchies to explore spatial strategies for a new society. They retained however clear roots in the classical, architectural elements of Renaissance theatre, including inner rooms, balconies, and partition walls.

DOI: 10.1057/9781137368683

William Shakespeare's plays call for a standard repertoire of spatial situations, most of which were present in the courtyards of Elizabethan inns where traveling players performed. Stage directions often called for an inner room within the stage to allow the audience, and perhaps an eavesdropping character, to peer into a more private realm, as for example, Friar Lawrence's cell, where Juliet cries, "O, shut the door!" to close out her family but not the audience.[16] Shakespeare made broad use of balconies that overlooked both the stage (for Juliet) and the audience (for a royal address). Occasionally the stage was split with a partition such that the audience (but not the characters) could see both sides. In the fable "Pyramus and Thisbe" played within *Midsummer Night's Dream*, a tradesman-actor played the wall with a chink in it through which the lovers courted. The wall is literally one of the characters in the drama, which defined the story poetically, with a wink and a nod to the audience.

To this set of dramatic places, modern set designers added stairs, ramps, and scaffolding that invited actors to move energetically. In 1919, director Jacques Copeau built a single set for the stage of the Vieux-Columbier Theatre in Paris, which provided architecture for all the plays he presented over the next decade[17] (Image link: http://library.calvin.edu/hda/node/2166). The set offered the Shakespearian spatial palette, as well as stairs, doors, and several platforms at various heights above the main stage floor, giving actors the full range of architectural situations, while avoiding painted illusion and flimsy construction typical of many theatrical productions.[18] Loyal patrons of the Vieux-Columbier who saw the same set again and again may have accepted it as part of the architecture of the theatre and over time discovered its dramatic potential.

Autant had worked with Copeau before World War I and he continued their association after the war. For Art et action's dramas, Autant further abstracted traditional elements of set design into spatial relationships defined along the three axes: vertically, in which one character stands on a platform raised higher than another; horizontally, where characters interact across a partition or split stage; and in depth, where part of a scene appears to be close and another far away. These divides set up the conditions for drama.

Inside/Outside

In 1927, Autant and Lara presented *Gulliver in the Land of the Dwarfs and of the Giants, a Drama Based on a Cosmic Theme.*[19] The one-act play

DOI: 10.1057/9781137368683

written by Autant was inspired by Jonathan Swift's eighteenth-century novel, yet bears no resemblance to the original story. In the performance, the play was followed by several improvised skits presented by the Comédie Spontanée, then a choral poem, "Hymne à la vie" (Hymn to Life). Thus, the single performance held at the Grenier Jaune, encompassed three types of theatre: Chamber theatre (Gulliver), Theatre of Space (Improvisation), Choral theatre (poetry).

In the text of the play, Autant took on the architectural distinction between inside and outside. For the set he placed a partition down the center of the stage to create two realms side-by-side with a single door in between. He fashioned Gulliver as the keeper of the door, the only opening between the world of the living and the world of the dead. Gulliver's task is to guide souls into the afterlife, like a Charon. Standing at the threshold, Gulliver is sympathetic to both realms, and able to cross freely from one to the other. In the land of the living, he guards a mournful cemetery landscape, a chilly expanse. On the other side, death appears as the cheerful interior of a tavern inhabited by the warm and lively souls of all who have once lived. The lonely living, ever fearful of death, remain on the outside, while the dead are social, sheltered, and inside.

The play turns on a paradox first stated by Gulliver's wife Gertruse (here he has a wife) "just look at your post as guardian of the cemetery, and your way out into the tavern."[20] The way out is a way in. The ambiguity compounds as the metaphor is developed. In the tavern the dead enjoy a collective memory of all people and all events in all time. They take pleasure in discussing art, science, and life, drawing references from across the sweep of history. If nothing else, the tavern is a nostalgic image of a Belle Epoch Parisian café frequented by artists and literati who held forth on any topic that would stir their audience. In Autant and Lara's Paris, cafés still spilled onto the sidewalk at every corner, continuing in their role as urban institutions that were both public and private, inside and outside.

Describing the tavern, Gulliver explained the beauty of conversations that well up from this collective memory:

> One must consider speech as music. All that a person can express comes from his or her full being and no one can argue with memory. It is pitiless, it charms us, excites us, embraces us, but it dominates us by its grandeur. Memory is the voice of our past, our artistic past, our scientific past, our spiritual past: it the infinite immensity of our knowledge.[21]

DOI: 10.1057/9781137368683

As the play proceeds, the encompassing power of shared, historical memory stands in contrast to the short-sightedness and fragility of life. The dead are revealed as giants with knowledge of all time, enjoying conversations that range over a broad landscape—an exterior. The living, on the other hand, are dwarfs who sorrow and regret, confined to the enclosure of their limited, private experience. Inside and outside are reversed once again.[22]

In Autant's play, the partition retained power as a division and the door as opening, but the qualities of the realms on either side were unstable. At the end of the play, the dead grant Gulliver and Gertruse, the keepers of the threshold, liberty to travel among the living as storytellers. At this point, Gulliver and Gertruse turned to face the audience. They will speak to those who will listen, telling stories of all times, and all places, which are simultaneously inside and outside of their world. Gulliver comments, "Man must live outside of himself." He embraces the duality of the threshold as a condition of thought itself.[23]

In Art et action's performance, "Gulliver" was followed by skits performed by Comédie Spontanée actors in distinctive black robes with yellow collars. Gulliver, the story-teller, asked the audience to suggest a place for action, characters, and an event; then he, Gertruse, and others in the troupe improvised the scene. In one performance, which Art et action recorded, the audience asked for a desert scene in which a grocery boy, a young nun, Don Quixote, a doctor, and Mimi Pinson (a popular singer) experience a "separation." The actors drew lines by pinning white bands of cloth to a black velour backdrop to indicate the desert and then played the scene. Three other scenes followed, each one increasingly abstract as the audience learned the game. In each improvisation, the setting, characters and event are absurdly disparate yet they form equal partners in the conversation. They chafe against one another to create stories that spring spontaneously from the actors' imagination in actions that Lara described as nourished by the immense collective memory of all time.[24]

These skits were followed by a third and final act. "Hymne à la vie" was a choral piece that began with random collection of recorded sounds and gradually coalesced into a musical order of pitch and harmony according to a mathematical progression, developing from dissonance to harmonies to speech.[25] In the progress of the music toward harmonic order, the sounds increasingly reinforced one another to create a spatial effect of increasing expanse, as if the music became larger. The piece

DOI: 10.1057/9781137368683

culminated in a song and finally a phrase, "Thus the world works," which reflected back onto the entire performance.

Taken together, the three parts of the performance developed a spatial theme. The play, "Gulliver," defined by a split stage centered on the duality of inside and outside, which was turned over and over in a series of reversals. This gave way to an interaction across the threshold between audience and actors to produce improvised skits. Finally, an atmospheric hymn celebrated cosmic unity arising out of differences and even discordances between sounds. All three pieces emphasized differences and the thresholds that defined the elements within a complex harmony.

Above/Below

In theatre, the stage itself is a platform that raises actors above the audience, makes them visible, and declares their actions noteworthy. Social hierarchy was often reinforced by a dais that raised the lord of the manor above others. Renaissance architect Inigo Jones gestured to these traditions in theatre by portraying an upper world of gods or ideal figures who oversaw and commented upon the machinations of characters below.[26]

Art et action refined the mythic power of vertical, hierarchical compositions in a 1929 performance of *Cain*, a drama written by British poet Lord Byron in 1821.[27] Byron presents Cain as a sympathetic character who, like Adam, questions God's grace. "He shows us paradise then takes it from us. He gives us curiosity then forbids us to use it. He gives us birth only to make us die. At least the apple gave Man reason." The published play included a theosophical interpretation, which cast Cain and Abel not as evil and good but as elementary opposites, like fire and water, which create and destroy each other in nurturing life. In this spirit, Art et action's set established a vertical hierarchy then inverted it in the course of the play.

As a Chamber Theatre performance, *Cain* was achronic, outside time. Adam, Eve, Cain, Abel, and their wives wore eighteenth-century costumes and occupied a parlor appropriate to Byron's time. Behind the domestic scene an upper platform stood at about elbow height to represent a celestial realm riding above the world below. The lower area of the stage was dark in comparison to the luminous upper world that was identified not as heaven but as Hades, Lucifer's afterworld. In one

DOI: 10.1057/9781137368683

striking image, Lucifer, dressed in diaphanous white and lit from behind, sat on the platform to speak with Cain's wife, who was dressed in black, standing on the lower stage. Her figure stood out in sharp silhouette against the white while her words challenged Lucifer: what good is knowledge if it separates a man from his family?

In the performance, Lucifer led Cain, stripped to a loin cloth, up to a position on the upper stage and gestured out toward the audience to indicate a view out over millions of souls "that surpass humans as much as they will surpass the 60,000th generation hence."[28] Lucifer's sweeping gesture gave the audience a role in the story as the descendants of Adam who bear witness to the story of Cain. In the Grenier Jaune, the audience occupied a position lower than the stage, which in the context of the story is as contradictory a position as that of Cain in the upper realm. The audience watching the play saw both upper and lower realms so their vision was as extensive as Cain's, yet they remained below, embodied, and damned by Cain's action.

In a white robe Lucifer seemed to float, while Cain's almost naked body was eroded by the bright light behind him. Lucifer spoke:

> All things are
> Divided with me; life and death—and time
> Eternity—and heaven and earth—and that
> Which is not heaven nor earth, but peopled with
> Those who once peopled or shall people both—These are my realms![29]

On the upper stage, out of place and out of his world, Cain saw everything in the light of knowledge. Aware that he could no longer control his circumstances, Cain returned to the ground to kill Abel and be forever damned. Byron's ultimate message is that Cain chose vision at the cost of damnation. In receiving that gift, the 60,000 generations bear the responsibility to use it well, to watch with perspicacity, and to act.

Autant and Lara set up contrasts between high and low, as well as light and dark, to define two realms of action. Their narrative was cosmological, but their means architectural. A position on a raised platform allows one to see and be seen. It is a realm of costume and mask, where a person can command the attention of all below them through voice and gesture. However, this perch weakens human contact. Someone on a balcony can observe what goes on below yet perceives only masses of people rather than individuals, and noise rather than voices. Cain's dilemma is that he gains vision but loses his body, his family, and his earth.

DOI: 10.1057/9781137368683

Art et action's performance ran parallel to a shift in modern architecture, which rejected the social position of a balcony overlooking the street in favor of broad roof terraces, private spaces not visible from below. In 1905 Autant built an apartment building in Paris with magnificent balconies designed so that residents could appear in elegance at every window on every level and look down to engage the street socially. From the modern roof terrace, in contrast, one looked to the sky or out to enjoy a wide panorama reaching to the horizon. The roof terrace was one of Le Corbusier's five points of architecture, a place where he envisioned modern people doing calisthenics in the morning sun.[30] Thus separated from social contact with the street, modern people could engage their natural bodies in a raised landscape that had more in common with an open field than a city balcony. Art et action's performance of *Cain* raised the paradox of this architectural shift: perhaps "natural man" alone under the sun is no man at all.

The drama of the stair

Cain presented two levels of play, but the liminal space of the stairs between them was neither visible nor part of the drama. Cain's transformation took place out of sight, and he appeared in Lucifer's realm as if he flew. Art et action's dramas emphasized opposing positions rather than movement. Yet stairs and ramps played a major role in modern architectural set design, offering dramatic potential that director Edward Gordon Craig explored in the first years of the twentieth century.

In *Towards a New Theatre*, Craig sketched four scenes on a broad flight of steps, each with a distinct mood that emerged in the gesture and movement of people (Figure 4.4). For example, in the third mood, a young woman in white descends the steps, as a suitor drawn in silhouette watches from below.

Craig wrote, "It does not seem to me very clear whether she ever does join him, but when designing it I had hoped that she might."[31] In Craig's sketches, the steps offer an indeterminate place between up and down with a sense of anticipation ready to emerge in a scene. She might join him, and might not. The stair suggests no specific place, but recalls familiar quotidian experience, revealing drama in the everyday.

DOI: 10.1057/9781137368683

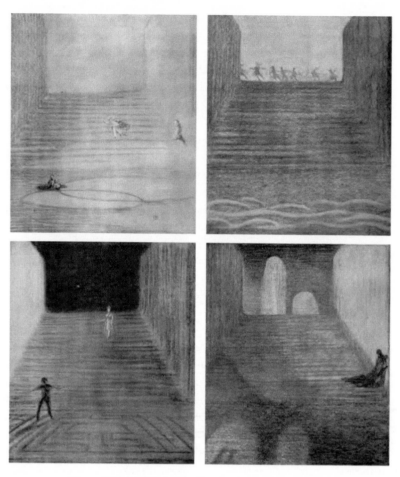

FIGURE 4.4 *Edward Gordon Craig, sketches for four scenes on the steps, 1913 (publication with the consent of the Edward Gordon Craig Estate)*

Stairs appeared in a number of Craig's sketches for stage sets. In 1908, he published a drawing for the Shakespearian scene in which Lady Macbeth rises from her bed still asleep, wringing her hands unable to wash off the blood of guilt, "Out damn spot"[32] (Image link: http://library.calvin.edu/hda/node/2125). Craig envisioned her alone at the top of a curved stone staircase that leads to an unknown depth. Hard and precarious, the steps proffer the sleepwalker only a descent made more foreboding by ominous figures that seem to emerge from the stone. The stairs are both a metaphor for her

DOI: 10.1057/9781137368683

anguish and a physical situation that an audience could understand viscerally.

Near/Far

Shakespeare's plays often indicated an inner room or scene within a scene, creating depth in both the set and the story. Art et action took a characteristically analytical approach to this spatial distinction, developing an architectural definition of near and far. Autant and Lara staged several plays, which defined layers of depth by progressively obscuring characters or limiting their expressive means. For example, in a performance of *The Wedding of Ryspianski*, actors downstage were fully visible to the audience; behind them others were seen as shadows projected onto a screen and still further back actors were hidden by a solid partition, so they were heard but not seen.

Art et action's interpretation of Voltaire's *Micromegas* in 1925 contained their most articulate exploration of distance, focusing on the transformations that images and voice undergo when transported from afar by media such as radio and cinema. Voltaire wrote the play as a satire protesting war, prejudice, and the shortsightedness of human society, yet Art et action remade it to their own ends.[33] Micromegas, a gargantuan visitor from the star Sirius, and a giant from Saturn travel to Earth fleeing the prejudices of their respective worlds. Micromegas is 8 *lieues* tall (about 34 kilometers) and has 200 senses while the Saturnian is 1000 *toises* tall (about 7 kilometers) and has 60 senses. Seeking a perfect society, they inspect the last place in the universe rumored to have intelligent life. Humans are so small that the Sirian can see them only through a magnifying glass and hear them only through a straw used as an amplifying horn. Micromegas and the Saturnian discover that tiny humans with as few as five senses are blessed with intelligence comparable to their own, yet human society also suffers the familiar ills of avarice, pride, and injustice. They are surprised that their human guide is able to calculate the height of both visitors by triangulating with a sextant: "The atom has measured me." Voltaire's text was pointed in the context of eighteenth-century global exploration and colonization and had lost little of its bite by the 1920s when France was struggling to keep her overseas empire.

In the Art et action performance, Autant and Lara adopted parts of Voltaire's text and added some of their own to address topical and

DOI: 10.1057/9781137368683

architectural issues. Themes of distance and a role for media first appeared in a prologue added by Autant and Lara. The host who introduced the play spoke of the celestial perspective that astronomy provides on this speck of dust we call Earth, a "point of view from Sirius." She invoked the zodiac of Egyptian, Hindu, Chinese, and Arab mythology then promised to show images. At this point, she darkened the room and called for slides to be projected on the wall. When they were not forthcoming, she apologized saying that the players must carry the performance. The play substituted for a missing slideshow. Micromegas entered dressed in the eighteenth-century style of Voltaire followed by the Saturnian who sat hunched like a dwarf with shaggy hair and a beard. After a bit of slapstick jostling, they discovered humans, marionettes, whom they see within a large semi-circular ring that suggested looking down the tunnel of a microscope. Micromegas and the Saturnian inquired into the state of human society: is it just, benevolent, wise? Are humans happy? As the play proceeds, the marionettes presented several vignettes that expose the absurdity of war, the treachery of law, and the ineptitude of love. True to Voltaire, the visitors discovered that no one in the universe enjoys true happiness, a dry relativistic conclusion.

Art et action's performance however emphasized Voltaire's musings on the senses: how do the limitations and peculiarities of our senses shape the nature of our knowledge? If humans can perceive Micromegas through only five senses, then they understand only a small part of the information that is available to his 200 senses. In the performance, Art et action's marionettes had blocky movements, no facial expression and remained out of the range of touch. They conveyed much less sensory information than the live actors watching them.

Lara had studied the marionette theatre in Russia. She wrote that marionettes make spectators aware of their alienation from the scene and require them to concentrate more intensely.[34] In *Micromegas*, the puppet play within a play in good Shakespearian fashion turned actors into audience and spectators into a meta-audience watching the watchers by looking through the scope of the stage. In this position they would be yet larger than Micromegas with yet more senses, and might also make the leap to picture themselves under the microscope of an even larger being.[35]

Edward Gordon Craig contended that since marionettes have fewer expressive qualities than human actors, they could convey an idea without the distraction of unintended movements or expressions.[36]

DOI: 10.1057/9781137368683

Inspired by Kabuki Theatre and Javanese puppets, Craig wrote that the theatre should eliminate actors altogether, substituting life size "super-marionettes" whose actions would be sharp and precise. Art et action's production of *Micromegas* contributed to this discussion by juxtaposing marionettes with real actors to emphasize their expressive differences, five senses versus two hundred senses, and by suggesting a parallel with modern media. The marionettes appeared as people seen through a microscope or telescope, instruments that expand vision. Modern devices, such as telephones, cinema, or radio, present "windows" into the distance but restrict communication to only one or two senses, shaping a relationship between near and far. The marionettes, presented as if they were seen through a viewing device, can be read as the promised slide show inserted into the play.

Art et action's performances of *Micromegas* and other plays bring into focus the effect of distance and media, which bring some features into focus and leave others out. Their work suggests that silent images of cinema and the disembodied voice of radio, which require the viewer/listener to concentrate intensely, might convey an idea with more purity than natural, multi-sensory conversation. In the 1920s, many such technological windows opened into daily experience and into architecture, each with a different character and a role in relation to the others. By isolating one sense from another, they challenged and broadened the act of watching.

Art et action's set designs for Chamber theatre explore how architecture defines the spectator. Autant and Lara explored how architectural frames, levels, and thresholds create separate realms and articulate the view in between. They built simple sets that presented spatial oppositions between high and low, near and far, dark and light. The actors physically navigated contrasting positions and the thresholds between. In every performance they cast the audience in the story as spectators who watch from a specific architectural position that reflects poetically on the act of watching itself. Finally, they addressed modern media, which opens windows for specific visual or auditory links across a distance, windows that might be woven into the fabric of buildings.

The Chamber Theatre building in relation to Autant's other theatre buildings demanded focused, intimate concentration by isolating spectators and establishing a clear threshold between the audience and the stage. Performances opened a window into a fictional realm where some features were emphasized and some diminished in order to sharpen the

DOI: 10.1057/9781137368683

specific channel of dramatic communication. The intense concentration required by Chamber Theatre was distinct from the excitement and distraction of the Theatre of Space, the collective absorption of the Choral Theatre, the discourse of the Theatre of the Book and the analysis of the University Theatre. Autant and Lara loved the Chamber Theatre best and explored in this genre the most subtle architectural channels for contact.

Notes

1 Max Deauville (1881–1966) Belgian doctor and writer who served in World War I. See Max Deauville (1931) *Ecce Homo* (Paris: Editions du Murier). "Ecce Homo" are the Latin words used by Pontius Pilot when he presented his prisoner Jesus Christ to a hostile crowd. Friedrich Nietzsche used the phrase in the title of his last work: *Ecce Homo: How One Becomes What One Is* (1888), a reflection on his own value as a philosopher and a man.

2 Art et action, "Le Théâtre de chambre," in *Cinq conceptions de structure dramatiques modernes* p. 1.

3 Tairov introduced abstract sets designed by Georgii Yakulov, Alexandra Exter, and Alexander Vesnin to a receptive Parisian avant-garde. In 1922/1923 Tairov also presented *Salome* (set by Exter), and *Phedre* (set by Alexander Vesnin).

4 See: *Giroflé Girofla* directed by Alexander Tairov, set designed by G. Yakulov, at the Théâtre des Champs-Elysées in Paris, 1922.

5 Alexander Tairov (1969) *Notes of a Director*, ed. H. D. Albright, trans. William Kuhlke (Books of the Theatre; Miami: Univ. of Miami) p. 119.

6 Tairov "La tragédie optimiste" (1932) in Alexander Tairov (1974) *Le Théâtre libéré* (Paris: L'Age d'homme la cité) p. 171. See also Georgii Kovalenko (1991) "The Constructivist stage," in Nancy Van Norman Baer (ed.), *Theatre in Revolution* (San Francisco: San Francisco Museum of Fine Arts, Thames and Hudson), 128–43, p. 146.

7 Corvin, *Le Théâtre de recherche entre les deux guerres: Le laboratoire Art et Action* p. 157.

8 Craig, *On the art of the theatre* p. 31.

9 Louise Lara noted that the partitions and the clear separation of the stage give spectators a sense of distance so they must concentrate more intensely. Corvin, *Le Théâtre de recherche entre les deux guerres: Le laboratoire Art et Action* p. 284. See also Art et action, "Le Théâtre de chambre."

10 Georges Polti (1867–1946) French writer and theorist of drama. See Georges Polti (1916) *Thirty-six Dramatic Situations*, trans. Lucille Ray (Boston: The Writer's Inc) p. 121. Corvin writes, "Polti was very close to Autant. He was a

DOI: 10.1057/9781137368683

free thinker, an anarchist and believed that only the Middle Ages understood art." p. 41.

11 Tairov recounted the evolution of the chorus and third actor in Tairov, *Notes of a Director* p. 137. Craig also told the history of theatre as a decline from ancient clarity and advocated a return to ancient technique. See Craig, *Towards a New Theatre; Forty Designs for Stage Scenes* pp. 6–8. "It was the movement of the chorus that moved the spectators." Auguste Perret also recounted the history of theatre buildings, making reference to the chorus. Perret, "Le Théâtre," p. 2.

12 Georges Albert Maurice Victor Bataille (1897–1962) French essayist who drew on Medieval mysticism to challenge cultural mores. See Georges Bataille (1929) "Architecture," *Documents*, 2 (May 1929). The essay was republished in Georges Bataille (1991) *Documents* (Paris: Jean Michel Place). See also Denis Hollier (1989) *Against Architecture: The Writings of Georges Bataille*, trans. Betsy Wing (October; Cambridge, MA: MIT Press) p. 47.

13 Seminal works in this area include Michel Foucault (1977) *Discipline and Punish* (NY: Pantheon), particularly Foucault's analysis of the Panopticon prison Panopticon, and Henri Lefebvre (1991) *The Production of Space* (Cambridge: Blackwell), a Marxist analysis of architecture.

14 See: Set design for *The Magnanimous Cuckold*, Popova 1922.

15 Barris, "Culture as Battleground: Subversive Narratives in Constructivist Architecture and Stage Design," p. 115.

16 MacGowan, *The Living Stage* pp. 167–70.

17 See: Jacques Copeau design for Vieux-Colombier Theatre in Paris, 1919.

18 Craig argued that painted scenery with perspectival illusions limited actors' movements. If they strayed too close to the backdrop or too far to the side then actors would look unnaturally large or out of place against the painted space. Craig, *Towards a New Theatre; Forty Designs for Stage Scenes* p. 12.

19 Art et action (n.d.-b) *Gulliver au pays de nains et au géants*, Fond Art et Action, Archive des Arts du Spectacle, Bibliothéque Nationale de France (Paris); bound volume contains typescript of play, descriptions of improvisation performance and score of "Hymne à la vie".

20 Art et action, *Gulliver au pays de nains et au géants*, p. 4.

21 Art et action, *Gulliver au pays de nains et au géants*, p. 22. « Il faut considérer la parole comme une musique, mais tout ce qu'un etre peut exprimer part de tout son etre et nul ne peut discuter un souvenir. Il est impitoyable, nous charme, nous emeut, nous etreint mais il nous domine par sa grandeur. Le souvenir c'est la voix de notre passe, passe artistique, passé scientifique, passé spirituel: c'est l'immense infinie de nos connaissances. »

22 The complexities of inside and outside were also present in Swift's original story of Gulliver. The giant Brombagnagians are active, physical beings

DOI: 10.1057/9781137368683

associated with the outdoors while dwarf Lilliputians are precise and intense, preferring indoor activities. See Susan Stewart (1993) *On Longing* (Durham, NC: Duke University Press) pp. 86–89.

23 Art et action, *Gulliver au pays de nains et au géants.*

24 Louise Lara's training course for the Comédie Spontanée Moderne centered on soliciting this type of response, arguing that they drew on collective memory. See Art et action, *Cours de comédie spontanée moderne (1e, 2e et 3e année) technique et réalisations.*

25 Art et action, *Gulliver au pays de nains et au géants.*

26 See John Peacock (1982) "Inigo Jones' Stage Architecture and Its Source," *The Art Bulletin*, 64/2, 195–216.

27 George Gordon Byron (1788–1824) British poet and leading figure in the Romantic movement. George Gordon Byron (1923 (1821)) *Cain: A dramatic mystery in 3 acts translated into French and refuted in a series of Philosophical and Critical Remarks by Fabre d'Olivet*, trans. Nayan Louise Redfield (London: G. P. Putnam). This curious volume in two languages may have been Autant's introduction to the play.

28 Byron, *Cain: A dramatic mystery in 3 acts translated into French and refuted in a series of Philosophical and Critical Remarks by Fabre d'Olivet* p. 101.

29 Byron, *Cain: A dramatic mystery in 3 acts translated into French and refuted in a series of Philosophical and Critical Remarks by Fabre d'Olivet* p. 94.

30 Colomina's analysis posits that Le Corbusier defined a raised position for an unseen viewer, a male position of dominance over the horizontal (and female) landscape. Colomina, *Privacy and Publicity* p. 114.

31 Craig, *Towards a New Theatre; Forty Designs for Stage Scenes* p. 45.

32 See: Edward Gordon Craig. Scene for MacBeth, Act 5, Scene 1 (The Mask 1 No. 5, July 1909, p. 223).

33 Art et action and Akakia Viala (1925) *Micromegas*, Fond Art et Action, Archive des Arts du Spectacle, Bibliothéque Nationale de France (Paris). Akakia notes that Renan first proposed a "point of view from Sirius' to give perspective on the speck of dust we call Earth."

34 In notes to an exhibition of Art and Action's work, 1938. Referred to in Corvin, *Le Théâtre de recherche entre les deux guerres: Le laboratoire Art et Action* p. 284.

35 Shakespeare used the play within a play often, most famously in Hamlet. "The play's the thing. Wherein I'll catch the conscience of the king" Act 2, Scene 2, lines 581–82.

36 Craig, *On the Art of the Theatre* p. 53.

DOI: 10.1057/9781137368683

5
Civic Debate: University Theatre

Abstract: *Autant and Lara's fifth theatrical genre framed moral questions for intellectual debate. Drawing on Jean de la Fontaine's fables and Montesquieu's essays, Autant wrote plays that established a scene and counter scene intended to spark Socratic discussion in an academic forum of professors and their students. Autant's sketch for a theatre building shows a frank, day-lit space that eschews theatric illusion, resembling a classroom more than a theatre, where discussion might develop. Within Autant and Lara's urban scheme, the University Theatre defined a civic space insulated from the market and from direct politics, where philosophical questions of morality and social values might be debated at the intellectual heart of the city.*

Read, Gray. *Modern Architecture in Theatre: The Experiments of Art et Action.* New York: Palgrave Macmillan, 2014. DOI: 10.1057/9781137368683.

In a series of three performances at the Sorbonne in the early 1930s, Art et action presented a genre of theatre designed to generate discussion among professors and students. They described University Theatre as a "theater of opposites, to awaken the mind of the student."[1] The plays interpreted literary works that framed philosophical or moral questions: essays by Montaigne, for example, and satires by Voltaire, which were presented by actors to serve as a prelude or prompt for a formal, academic discussion. In a long essay to accompany the 1933 publication of his University Theatre plays, Autant criticized traditional pedagogy that centered on developing the "seeds of knowledge" rather than "the ground in which they are sown," in other words, centered on facts and ideas rather than on developing the creative minds of students. He proposed a theatre of discussion as an alternative to dictatorial lectures, writing, "Creation is the greatest human joy...we are not concerned with moral discipline or dogmatism but the pure satisfaction of the liberated soul."[2]

In a prologue to his essay, Autant assembled the "quintology" of dramatic structures, bringing the whole scheme into focus as a comprehensive proposal for the role of theatre in modern life. He described each of the five theatres as the appropriate vehicle for a specific type of drama and experience, "If I go on land, I travel on foot or in a car; if I go by water, I travel in a boat; if by air, a balloon or plane is essential; thus it is for the places I go and the particular interests I pursue."[3]

The fifth scheme of the quintology, the University Theatre, takes a position as a theatre of creative discussion that is open to the serious-minded yet protected from the material interests of politics and the marketplace (Figure 5.1). Autant cited Aristotle to define "*dianoia*" as creative thought that contributes to the ongoing discourse of human culture. In Aristotle's vision of a just state, this genre of thought was the heart of *paideia*, a celebration of dialogue based on Plato's academy, where leading citizens could engage each other in open debate on matters of common interest, and young men could learn the art of rhetoric as a method of both competitive dialogue and intellectual inquiry.[4]

Both Art et action's Sorbonne performances and the un-built theatre building propose a place for discussion, specifically dialectical conversation between the actors within the play and between professors and students outside of the play but still within the University Theatre performance. The plays framed ideas through a scene and counter-scene, often characters drawn from literature who develop opposing points of view on a philosophical issue. In one skit that Art et action presented

DOI: 10.1057/9781137368683

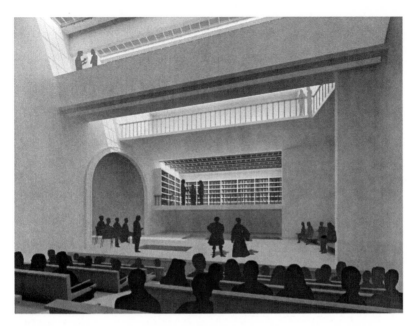

FIGURE 5.1 *Interior view of University Theatre (Théâtre Universitaire) based on Autant's sketches (Damir Sinovcic and author)*

the comic doctor devised by Voltaire. Pangloss espouses the optimistic philosophy of Leibniz and is countered by the pessimist Candide. In other short scenes that Art et action listed as University Theatre, characters debated topics such as free will, justice, and reason. Autant specified that the debate enacted in the play was intended to precipitate a formal dialogue between professors and students. In their academic roles (and perhaps robes), each watched the play and then spoke to address the philosophical issues raised there, presenting opinions or making reasoned arguments before colleagues assembled in the hall.

In Autant's overarching scheme of five theatres, University Theatre models the performance of an outward-looking civic life as opposed to personal introspection, and of high culture as opposed to popular culture. It offers an intellectual as opposed to emotional experience, and asks spectators to participate actively rather than vicariously in the action. Performances in the University Theatre address ideas rather than emotions and are visually linked to their surroundings, not isolated from them. As part of Autant's architectural scheme, the University Theatre proposes the place and performance of public intellectual life at the

DOI: 10.1057/9781137368683

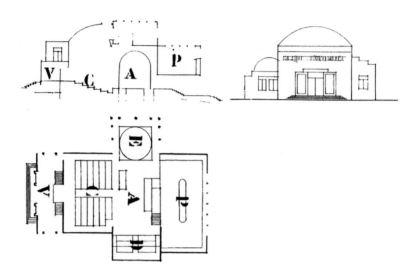

FIGURE 5.2 *University Theatre sketches by Autant (Courtesy: Corti Press)*

Note: Plan shows stage with access from below surrounded on three sides by spectators grouped according to status in the university and on the fourth side by a library. Section shows trap doors on stage floor, suspended library and arch to area for professors. Elevation shows domes over audience and over area for professors. Key: Center Stage with access from below (A); Room reserved for auditing students and special spectators working at the Sorbonne such as selected visiting students (C); Room reserved for drama students during the school year and graduates who have not taken the state examination for teaching (D); Room communicating with library reserved for Principle of the Academy, Professors of the Sorbonne and participants in the program of performances (E); Library, containing the basic catalogue of the central library and full catalogues of specialty libraries (P); Entry Hall (V).

highest level of society, where weighty moral and philosophical questions of great importance to the community are discussed. The layout of the University Theatre can be read as a proposal for civic education based on Athenian *paideia* and thoughtful debate of ethical principles.

Autant's sketch for the theatre building places the stage at the center of a cruciform plan with professors to the left, graduate students to the right, and a raised library behind the action, all visible to an audience of auditing students and visitors (Figure 5.2). The façade view shows a domed hall like the Choral Theatre, invoking a tradition of monumental buildings that create a world within the world, covered with a miniature sky. The two domed theatres bracket Autant's series suggesting that they, like sacred and civic buildings in traditional cities, should be urban landmarks, embedded in the structure of the city.

DOI: 10.1057/9781137368683

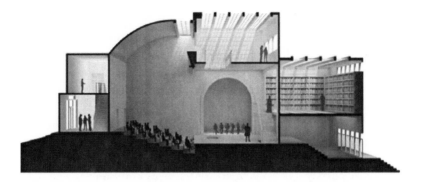

FIGURE 5.3 *Section of University Theatre, showing stage at center, library on mezzanine level to right, and alcove for professors (Damir Sinovcic and author)*

The library of the University Theatre is new element. Behind the stage and raised to the second level, it overlooks the entire scene as arbiter, recalling the chapel at the Sorbonne, which overlooks the campus courtyard. The position of the library confirms the link between performances and scholarship, as if the collective wisdom of the past witnesses the proceedings. In the panoply of Art et action's work, the library also might invoke the ancient chorus as omniscient mediator, and perhaps Gulliver, the storyteller of all time, who moves between the living and the dead.

The University Theatre is an academic space similar to the Theatre of the Book, yet presents a setting for public discourse rather than analytical discussion within a class (Figure 5.3). With the stage at the center, giving locus to the topic on the floor, the professors and graduate students face each other as if to constitute opposing sides in a debate. The professors are framed by an archway and covered by a small dome so that their presence would seem larger, suggesting the position in Renaissance theatre of nobility who sat on the stage as they watched the play and were watched by the audience. The professors enter and exit from the side via the door to the outside. On the other side of the hall, the shallow alcove enclosing the graduate students balances the symmetry. This hierarchical grouping implies an academic progression from auditors, to graduate students, then professors and finally the library, housing the wisdom of the past.

In the University Theatre, as in the Chamber Theatre, spectators surround the play and see each other across the space. Actors rise onto the stage from below, appearing and disappearing as if conjured for the occasion. In the University Theatre, however, actors provide a prologue

DOI: 10.1057/9781137368683

to the real performance—the discussion. They serve as provocateurs. In the hall spectators would recognize one another in their academic roles as members of an intellectual community. In addition, no spatial gulf separates spectators from performers; indeed, the graduate students must walk across the stage to reach their seats. The stage serves both actors and speakers from the audience in a performance sequence of a scene followed by a debate.

Like the Theatre of Space, the University Theatre has skylights above the stage suggesting that plays would be performed in daylight so performers and spectators would be equally visible to each other. The changing angle and intensity of daylight would mark the passage of time during a performance. Autant's section also shows an apparently unobstructed opening to the outside behind the stage and underneath the library, so the view behind the play would fall away into depth, perhaps toward the adjacent buildings of the university and the surrounding city. This arrangement grounds the discursive space of the University Theatre in the city and under the sky.

Theatre of intuitive learning

In Autant's introductory essay to the University Theatre, he excoriated traditional pedagogy (specifically, academic lectures) as didactic recitations that recount only the opinions of the victorious. As an alternative, he proposed theatre, which invites students to physically enter the passionate debate of ideas embedded in historical events. He wrote that a literary work can only truly exist as an interior projection of the mind actively created by the reader, a process he termed *connaissance*, in the sense of knowing or feeling with a person, in contrast to *savoir*, or knowledge of facts. Autant argued that theatre could open historical ideas through dialogue, so that students might listen to the merits of both sides of a question, then participate in the debate. He insisted that such intellectual drama not resolve oppositions but rather invite students to experience the conflict and open their minds to contradiction as a condition of thought. Autant termed this approach "Sympolyhistoricism," seeking the poetry in historical debate.[5]

Autant's design and performances for the University Theatre focused on the position and roles of spectators rather than performers. Autant insisted that spectators remain aware of their real position, not sink into mere entertainment. And, he went even further in University Theatre

DOI: 10.1057/9781137368683

performances, asking spectators to actively enter the debate rather than maintain a detached intellectual critique. Autant's architectural and staging strategies worked paradoxically, first to distance spectators from the play so that they might experience the real world in parallel with the narrative of the author, and then to call on them to participate, both physically and intellectually, so that they entered the arena of performance.

Autant wrote that spectators should experience mental contact between "here" in the theatre and "there" in the past reality of the author. He held that the experience of University Theatre events should be unified and must "avoid that fragmentation of the mind that is, on the contrary, characteristic of current theatre shows that replace interest by variety, which is essential if one only wants to entertain—to avoid thinking."[6] He continued, "The University Theatre must, on the contrary, constantly lead the mind back to the topic under examination, resisting anything that would give too much liberty to mere representation." The value of theatre for teaching, he argued, was that students could bodily enact the ideas from the past with a sensual presence that they could both feel and think. He warned against extended dialogue or intrigues of plot that might distract the spectator from sensing, almost physically, the intellectual development of the theme. "Mental contact cannot take place but as a function of the atmosphere. Physical reactions progressively intervene and in the end dominate until one senses the ideas of the author."[7]

The size of the hall and of the group was crucial to the University Theatre endeavor. Autant wrote that the stage for the participants must approximate the size of a normal classroom (not including the auditors), for neither large classes nor individual lessons could achieve an atmosphere of collective discussion. In Autant's scheme, the question of size was charged with ideological significance. One of the purposes of education in a socialist society was to move students from thinking of themselves solely as individuals toward identifying with the collective, "to pass systematically from the individual to the crowd." Autant wrote that this transition was more spiritual than political for he saw true immersion in the collective as a manifestation of individual enlightenment, a recognition of the immensity of life and a desire to engage the creative conversation of thought. "Individual pride is extinguished in the realization that one's effort is only an affirmation of the persistent study of many previous generations."[8] He argued that the collective action of theatre speaks to students individually, drawing them into a shared conversation with each other, with their professors, with the "radiant" ideas of the author

DOI: 10.1057/9781137368683

presented on stage, and with the collective wisdom represented by the assembled academic community and finally, the library. This conversation had to take place among a group that was both small enough to allow each individual to speak and large enough to represent a community.

Autant wrote that intellectual conversation gains depth through the contributions of multiple voices drawing on historical memory and has impact within the larger community. The disciplined thought fostered by the University Theatre built on the historical discussions embedded in literary works, and was intended to lead to further discussions, which in turn might inspire new essays or stories. He sought to engage the continuing flow of ideas that extends deep into the past and surges forward through the voices and pens of those who learn and teach. In a flourish of enthusiasm, Autant wrote that all literature is as a magnificent sentence in which each masterpiece is a word; even the contradictions between them do not impede the run of thought that is never complete.[9] The University Theatre celebrated this cultural conversation, making it visible to the community in a controlled but quasi-public forum.

Art et action presented "The Essays of Montaigne," a series of short plays in which lines from Montaigne's essays are interspersed with commentary. In one skit, "Of Moderation," three crazed convicts take the part of "violence" and three spinsters in their parlor represent "virtue." Their discussion centers on whether excessive virtue leads to violence. Each character presents an aspect of Montaigne's shifting argument, which draws on classical stories to circle the question. For example, one of the convicts related the story of the emperor Posthumius, who had his son killed for excessive ardor in running ahead of his battalion to attack an enemy. In response one of the women spoke of the emperor Aelius Verus, who answered his wife's complaint about his mistresses by arguing that a virtuous marriage is to be honored with dignity, while folly and lust belong elsewhere.[10] Montaigne appeared out of a backdrop that resembled a huge book to make pronouncements that commented on the discussion. Important phrases were projected onto the leaves of the book to emphasize the literary source.[11]

University Theatre and Henri Bergson's *Élan Vital*

In describing University Theatre performances, Autant explicitly defined human knowledge not as encyclopedic or fixed but as made up

DOI: 10.1057/9781137368683

of many voices with many experiences and expressions that could not be reduced to a single history or correct point of view. He went further to write, "We have many collective characters within us, the soul of a hive, the soul of a crowd, the judgment of a room of spectators, so different than the judgment of each of them."[12] Autant also quotes the acerbic, Enlightenment-era essayist Jean de la Bruyère who maintained, "men have no character at all," to describe individuality, or the "I" as multiple, already a "tumultuous parliament" that at base has no real or constant unity.

The extent of the ideas underlying University Theatre, and the entire "quintology" of theatres, emerges more fully in light of Henri Bergson's philosophy. In *Matter and Memory*, published in 1896, Bergson defined the individual as a complex of experiences, yet more than the sum of those experiences, like a city that offers an artist many views yet is more than the sum of even its infinite views. Bergson argued that each experience has a duration in time through memory, extending back into multiple past events like threads that a spinner gathers into yarn. The creative act of spinning, whether by a person or group, generates new memories that feed new experiences in ever-changing interactions that weave a new and open-ended future. Bergson goes to lengths to argue that by acting freely, we enrich the human spirit and advance the force of life—*élan vital*—toward a higher level of consciousness.[13]

In describing the didactic goals of the University Theatre, Autant drew on Lara's experience training actors in improvisation for the Comédie Spontanée Moderne, to invoke a distinction between *memoire* and *souvenir*, which both translate into English as "memory." *Memoire* is rote memory, which was the basis of standard educational practice. Students memorized their lessons as actors memorized lines for a play. *Souvenir*, on the other hand, he characterized as personal memories with emotional weight, which one recalls in the body as well as the mind. Lara's method for improvisation, probably modeled on that of the Russian teacher and actor Konstantin Stanislavsky, involved inhabiting a character by building on one's personal *souvenirs* to reach a felt understanding of another's inner life. Similarly, Autant described the University Theatre exercises as a method by which students might enter the intellectual dilemmas of the past and establish contact between their own physical thoughts and those of the author. This experience requires spectators to actively and critically engage the ideas, as if from within, in order to create a unified *souvenir*.

DOI: 10.1057/9781137368683

Autant and Lara's careful distinction parallels one that Henri Bergson developed between intellect and intuition. In *Creative Evolution*, published in 1911, Bergson described how the *élan vital* drives two apects of human thought. Intellect, he argued, is a form of consciousness that allows us to see things and phenomena from the outside, as systems that may be dissected into parts and explained by mathematical laws. This scientific view treats time as an abstract interval between static states that is theoretically reversible and separate from matter. Intuition, on the other hand, is a form of consciousness that emerges within the flow of time and events rather than outside of it. Intuition is direct rather than indirect knowledge, emerging from within the transformations of growth, reproduction, and death, like the ability of individual bees to know what to do in the moment in relation to the actions of other bees, without a concept of the hive or a leader. Bergson argued that all living things partake of both kinds of consciousness to some degree, even if they are dormant as in plants. And all are driven to perpetual growth, "a creation without end," which runs counter to the tendency of matter toward entropy.[14] This process, with many divisions and dead ends, is evolution, which produces the infinite variety of complex creatures in a multiplicity of forms. Bergson embraced evolution but challenged the positivism implicit in Darwin's theory by arguing that evolution is not only pushed from behind by natural selection but is drawn forward by the thrust of life toward consciousness.[15]

Bergson argued that while the human mind is drawn to intellectual inquiry, instinct has been neglected in Western society. Instinct, he wrote, is our ability to sympathize with another person in the sense of feeling with someone:

> If this sympathy could extend its object and reflect upon itself, it would give us the key to vital operations, just as intelligence guides us to matter...This intention is just what the artist tries to regain, in placing himself back within the object by a kind of sympathy, an effort of intuition to break the barrier between him and his model. This intuition pertains to the individual but we can conceive an inquiry turned in the same direction as art, which would take life in general for its object, just as science takes individual observations into general laws.[16]

Bergson's argument suddenly expanded. If instinct, the purview of artists, sees from within life rather than from outside, it touches the creative force of *élan vital* more directly than intellect and might

DOI: 10.1057/9781137368683

impel consciousness higher than yet known. Intuition could drive a new form of inquiry that could complement the scientific view with knowledge drawn from within life itself. In the culminating step of his critique of Darwinian evolution, Bergson defined intuition as the *élan vital* itself, which includes intellect as a specialized facility of mind. Intuition inhabits matter, from the simplest protozoa to the human being, driving the creative engine of evolution forward toward higher levels of organization, in both body and mind, toward consciousness that is freedom itself.[17]

Returning to the University Theatre, if Autant and Lara embraced the full extent of Bergson's scheme, then their goals appear neither modest nor confined to the realm of the performing arts. The University Theatre, as presented in Autant's philosophical essay, emerges as a means to bring the intuitive, artistic efforts of theatre—particularly Lara's spontaneous method of acting—into a position parallel to intellectual, critical reasoning.

Art et action's performances seem to merge intuition with intellect at several levels. First, the literary works chosen for enactment were essays by writers such as Montaigne, who combined intellectual parry with personal recollections in poetic language that invited the reader to enter his argument sympathetically as well as logically. Secondly, the author's words were embodied by actors (or students) who enter a character physically in movement and gesture, yet the day-lit theatre and face-to-face seating held spectators at a critical distance. Students simultaneously entered into the characters sympathetically and remained outside intellectually. Thirdly, introducing theatre into the context of the university placed one of the most intuitive arts into the bastion of academic pursuit. By rendering literary essays as a theatre of debate, Art et action invited the intuitive consciousness of students to empathize with the authors' ideas at the center of intellectual analysis. The final step of Bergson's scheme posits that human intuition contains intellect at the pinnacle of natural evolution, pressing forward to new heights of creativity.

Through the lens of Bergson's philosophy, Autant's overarching scheme of five theatres comes into focus. Each theatre draws out a distinct aspect of intuition, which appeals to spectators through their sympathetic sensibilities. In the order they are presented, each also builds on the last toward a mature intuitive inquiry. In the introduction to the University Theatre, the theatrical intentions of each theatre are explained as part of the larger goals of the "Quintologie."[18]

DOI: 10.1057/9781137368683

The first is always the Chamber Theatre centered on the human voice in the multiplicity of simultaneous poetry, which juxtaposes word and music spatially. Autant quoted René Ghil:

> What would be the human voice without the purpose of expressing the harmonious life of worlds at every height and at all sequences and extended in all directions, ideal waves of thought that join the waves of the universes; the horizon and the undulation of the sea and the wind, the pulsation of mayflies, of our blood and of our spirit.

To posit a link between the vibrations of the voice and those of life and the universe perhaps overstates the confluence that Bergson found between intuition, instinct, and the force of life toward creation, however it places spoken poetry at the center. The unity in multiplicity of poetic voice as it emerged from random sound in the Chamber Theatre performance of "A Hymn to Life" can be read as the intuitive voice of art.

The improvised performances of the Theatre of Space by Lara's Comédie Spontanée Moderne liberated the actor's body to move intuitively in both the real space of the theatre and an imagined elsewhere of a story. Spectators were surrounded by multiple scenes that told mythic stories, linking ordinary actions with the larger rhythms of the universe by way of poetic intuition. Engaged simultaneously with each other, the actors, and a real landscape, they made imaginative leaps between the parts.

Performances of the Theatre of the Book spanned a visual scene and the spoken word by generating conversation among spectators. The layers of theatrical distance from visual tableaux and staged commentary to read text and spontaneous discussion among groups of spectators, elaborated the performance, made it multiple, and invited both actors and audience to enter. The Theatre of the Book also drew specific historical and literary allusions from across time into the on-going event in the present. Intuition lay in the flashes of contact between narrative, action, and discussion that emerged spontaneously among people.

The Chamber Theatre took a contrasting approach to intuitive inquiry by isolating spectators as individuals where they might subjectively experience dramas chosen for their concentration of spirit. Alone, they could enter a character emotionally without reserve to feel what a character felt in a spatial as well as dramatic situation. By promoting the practice of sympathetic projection, performances developed skills of intuition in the spectator in the same way that the exercises of the Comédie Spontanée did in the actor.

DOI: 10.1057/9781137368683

The University Theatre culminated the series by bringing spectators back into their real social roles and heightening conversation into public performance. Through dramatic empathy and intellectual discussion, the voice of the collective emerged to heighten intuitive/intellectual pursuit.

Throughout the series, and in University Theatre performances in particular, Autant betrays a Marxist interpretation of Bergson that extended the role of the *élan vital* in natural evolution toward social evolution, culminating in a collective society. Yet in the early 1930s when he wrote, Autant retained the voice of an artist rather than a political advocate. Embracing Bergson's definition of intuitive consciousness as "freedom itself," he argued that the collective society must be based in creative liberty. At the end of his philosophical essay on the University Theatre, Autant turned not to Marx nor to the realities of urban institutions, but to a spiritual interpretation of Bergson's philosophy that he had inherited from the Symbolist poets and first articulated in the Choral Theatre, to unite the life force with the musical vibrations of the universe.

In the 1960s, when he was more than ninety years old, Edouard Autant attempted an electronic theatre that conjured an old Bergsonian idea. He imagined that through direct transmission in electromagnetic waves, the ideas of the author, the dramatist, and the spectators could mingle in an ethereal atmosphere beyond sound. And like Edward Gordon Craig, he proposed replacing actors with plastic puppets capable of dramatic expression from the most human to the most fanciful, which could make an author's thoughts visible.[19]

The urbanism of the University Theatre

Of all the theatres, the University Theatre is perhaps the most socially idealistic of Art et action's proposals. As theatric, rhetorical play, or *paideia*, it parallels and comments on education and institutions centered on debate, such as parliamentary government and courts of law, where momentous decisions are made under the eye of the populous. The University Theatre was designed to train young people through intuition to think, feel, and speak from within the collective sweep of history.

The architectural situation is explicit. The small size of the hall (like a classroom), the central floor, the symmetrical groups facing each other,

DOI: 10.1057/9781137368683

the audience as witness, the commanding presence of the library, and the openness of the hall to the outside set up conditions for discussion within a small community of intellectuals, who in some sense listen and speak on behalf of the general populace.

Parlement was established in Paris in the fourteenth century as a quasi-independent king's council and court of law. The national parliament in France retains a bicameral structure of Senate and National Assembly that dates from the French Revolution, in which the Senate, literally the "elders," holds a higher position in the legislative hierarchy. Each house now deliberates separately, but on occasion the two convene at the Chateau of Versailles to debate constitutional questions.

French courts of law also developed out of the *parlement* with a formal structure for debate that even more closely resembles the University Theatre. The Palais de Justice in Paris contains the nation's highest court, *la Cour de Cassation*, in which arguments of legal interpretation are heard. The venerable courtroom centers on a rectangular floor flanked to the left and right by chairs for lawyers who argue the opposing sides of the case. At the top of the rectangle, three to five judges sit behind a desk on a raised dais. On the opposite side of the hall a gallery of spectators watch the proceedings. In presenting their case lawyers stand and step forward to take the floor, addressing their opponents, the judges, and the gallery. The floor is the stage of action between facing opponents, under the watch of the public and the presiding judges. Final opinions are recorded in the adjacent court library.

Autant and Lara's University Theatre takes a position parallel to the institutions of government and law, yet remains safely within the realm of education, where free and speculative discussion is not burdened with immediate choices. Performances address philosophical questions, yet approach them through literature rather than law. The theatre places spectators in hierarchical groups, yet sets up an egalitarian duality for dialogue, architecturally validating students' opinions as almost equal to those of their professors. The building is small in size yet monumental in demeanor, holding a position at the end of a series that began with the domed Choral Theatre, perhaps suggesting that collective consciousness develops out of individual consciousness. It proposes dialogue as a civic performance intimately tied to artistic intuition, generated by the many, reaching back into historical time, and given voice by the few.

DOI: 10.1057/9781137368683

Notes

1 Art et action, "Le Théâtre universaire," p. 31. in Art et action, *Cinq conceptions de structures dramatiques modernes.*

2 Art et action, "Le Théâtre universaire," p. 31.

3 Art et action, "Le Théâtre universaire." See "Analyse de la Quintologie des Conceptions de Structures" on page facing title.

4 Aristotle (2000) *Politics*, trans. Benjamin Jowett (NY: Dover), line 1328b2ff. See also Werner Jaeger's seminal work on *paideia*, which post-dated Autant's interpretation. Werner Jaeger (1945) *Paideia: The ideals of Greek culture*, trans. Gilbert Highet (2nd edn: NY: Oxford University Press).

5 Art et action, "Le Théâtre universaire," p. 21.

6 Art et action, "Le Théâtre universaire," p. 31.

7 Art et action, "Le Théâtre universaire," p. 9.

8 Art et action, "Le Théâtre universaire," p. 10.

9 Art et action, "Le Théâtre universaire," p. 17.

10 Art et action, "Le Théâtre universaire," pp. 112–18. See also Michel de Montaigne (2010 (1910)) "Of Moderation," in William Carew Hazlett (ed.), *Essays of Montaigne* (6; NY: FQ Books), chapter XXIX. Accessed from http://oll.libertyfund.org/title/108/219681 on 2011-06-02.

11 Art et action, "Le Théâtre universaire" pages preceding the text of "*Les Essais de Montaigne.*" In the description of the model for the set, the screen is described as a device to lead the public to participate.

12 Art et action, "Le Théâtre universaire," p. 18.

13 These ideas are developed in Bergson's *Matière et memoire* published in 1896. See Henri Bergson (1911) *Matter and Memory*, trans. Nancy Paul and W. Scott Palmer (London: George Allen & Unwin Ltd.). They are restated and extended in Henri Bergson (1919) "Introduction to Metaphysics," in Henri Bergson (ed.), *The Creative Mind* (NY: Greenwood Press), 187–237.

14 Henri Bergson (1944 (1911)) *Creative Evolution* (NY: The Modern Library) p. 199.

15 Bergson, *Creative Evolution* p. 63.

16 Bergson, *Creative Evolution* p. 194.

17 Bergson, *Creative Evolution* p. 294.

18 "Quintologie" a summary of the five theatres on the page facing the title page of "Le Théâtre Universitaire" in Art et action, *Cinq conceptions de structures dramatiques modernes.*

19 Corvin, *Le Théâtre de recherche entre les deux guerres: Le laboratoire Art et Action* p. 221.

DOI: 10.1057/9781137368683

Conclusion: The Performance of a Town

Abstract: *Together, Art et action's five types of theatre modeled the elements of a modern town to envision a collective society based on artistic freedom, community, and public dialogue. Although their work was not broadly influential, some of the larger ideas emerged in post-war art, architecture, and criticism. Recently Bernard Tschumi and other architects have embraced a theatrical approach to urbanism as part of an effort to build lively and sustainable cities. In this intellectual lineage, reconsideration of Autant and Lara's work can make a significant contribution by reweaving the traditional interconnection between architecture and theatre.*

Read, Gray. *Modern Architecture in Theatre: The Experiments of Art et Action.* New York: Palgrave Macmillan, 2014. DOI: 10.1057/9781137368683.

DOI: 10.1057/9781137368683

Autant and Lara addressed the theatre of urban life that took place all around them. They built on the metaphor of *theatrum mundi*, theatre of the world, a tradition that offers particularly rich ground for architectural imagination. Their work and that of their architect colleagues in the 1920s and '30s map how modern architecture might have developed if architects had embraced a theatrical metaphor and the challenge of urban life. Of course, the main stream of modern architecture took another course, pursuing a primary allegiance to the fine arts. Nevertheless, Autant and Lara's work offers a link back to an older tradition and projects forward to suggest how contemporary architects might refocus design on how buildings act with and among people. Their interpretation of the theatrical metaphor opens creative territory that is particularly relevant for architects now challenged with constructing urban life for vibrant and sustainable cities.

Specifically, they offer a systematic exploration of architectural position, how buildings place people in potent spatial relationships with each other. In set design they constructed narratives around positions high and low, near and far, and side by side. Autant's designs for the five theatres articulated exactly how actors and spectators would see each other and be seen in events that unfolded in time. Art et action's practice of the art of theatre spoke to the design of social spaces in the same way that aspects of modern abstract art such as the De Stijl movement paralleled and supported the development of abstract composition in architecture. In theatre they crafted architectural scale, position, and composition, not to create an object of vision but to spark creative contact.

Art et action's performances offer a provocation. Autant did not design buildings; rather, he told stories. His sets and performance spaces imagined architecture's role in the theatre of the city, making reference to the ancient role that buildings have always played and that which they might play in a more perfect society. His designs for the five theatres can each be read as stories or proposals, half in the realm of fiction, which might spur architects to think more fully about how buildings act in social events in the city. As theatres they are already set apart from daily life as a *theatron* or place of vision, where people come together to see and hear stories that open to larger ideas. Theatres already represent.

Looking at Autant and Lara's work now begs the question of how architectural theatre might be reconceived in a contemporary society, permeated by virtual communication. Architectural space, and particularly the spaces of social interaction, have the power to ground us in place

DOI: 10.1057/9781137368683

and time, defining for us a physical position in a physical world. The material sense of here and now provides an essential counterpoint to on-line spacelessness. As images become more and more vivid, the spatial, physical art of architecture becomes more and more vital. Experimental, architectural theatre has already emerged to complement design in the work of some architects, such as Elizabeth Diller and Ricardo Scofidio, who integrate media into spatial experience. Such architectural theatre might expand to explore spatial actions, tell stories spatially, and enact spatial potential in found situations, focusing exactly on the part of life that virtual experience cannot. This approach centers on architecture's fundamental task—creating spaces that support human society in the present moment. Paradoxically, theatre, the most unreal of the arts, can give back to architecture its essential role as the most real of the arts. In theatre, architects might rediscover a natural, creative ally for design, a place to develop spatial strategies that heighten urban life.

The art of watching

Autant and Lara labored in live theatre at the historical moment that modern media emerged into popular culture. They embraced the technologies of cinema and radio yet rejected the modern spectacle that offered only a passive role to mass audiences. Instead they used cinema and radio architecturally to heighten social events rather than to substitute for real, face-to-face interaction. For example the projection screen on the façade of the Theatre of Space was intended to bring the performances going on inside the building out to the street, where the images would add to the life of the city.

Art et action's performances explored the art of watching through five genres of events, each of which gave spectators a distinct role.

In all of their performances, Autant and Lara called on spectators to watch actively and creatively. Most types of performance had multiple simultaneous scenes, and images were often separated from words so what spectators saw was distinct from what they heard. To watch meant to construct meaning out of the disparate parts, a challenge that becomes more creative and poetic the more the parts are separated. The artistic simultaneity that Autant and Lara embraced has roots, through Guillaume Apollinaire to Surrealism, and is perhaps summed up best by Pierre Reverdy: "[A]n image is born from a juxtaposition of two more

DOI: 10.1057/9781137368683

or less distant realities and … the more distant and more true their relationship, the more emotional power and poetic reality the image will have."[1] During a performance, flashes of insight appear in the moment between those who act and those who watch.

Art et action's performances and Autant's architecture explored social spaces that are not purely public as for example mass gatherings and not purely private as intimate conversations, but spaces and events where watching and being watched are reciprocal to some degree. In all of Autant and Lara's five theatric types, spectators are visible to each other in one way or another, and the success of the event depends on spectators playing their role as those who watch.

Each genre of performance invoked the performances of social life. For example, in ritual, as in the Chamber Theatre the spirit is shared among people who sense a connection, even without looking at each other directly. The faith of the congregation as a whole inspires the faith of each individual in the charged atmosphere of the moment. Similarly, yet in the very different genre of Theatre of Space, the joy of a festival depends on seeing reactions and expressions of others, while being surrounded by many scenes going on simultaneously. The "sounds gestures colors cries tumult," as conjured by Apollinaire, engulf everyone in complex exuberance and everyone contributes. An exhibition, like Theatre of the Book on the other hand, offers quieter aesthetic contemplation and conversation. Exhibitions are considered successful when they generate responses from those who view them, which emerge in commentary outside the frame of the images exhibited. Finally, an academic debate as University Theatre is a formalized conversation that relies on speakers who act in their social roles. They perform without assuming a fictional character, so there is no threshold of narrative between speakers and listeners. In the course of a debate or academic conversation, speakers listen and listeners speak.

Taken together, the social performances explored in Art et action's theatres constitute the important events and institutions of a town. Each has a social and an architectural place in the tradition of classical urban design.[2] Autant's sketches for the façades of the five theatres indicate how they might fit into a city. Both the Choral Theatre and University Theatre buildings carry domes, identifying them as landmark buildings that invoke the gravitas of spiritual and civic events respectively (Figure 6.1).

They make reference to monumental churches and government buildings, such as Perret's Saint-Joseph placed in the center of Le Havre,

DOI: 10.1057/9781137368683

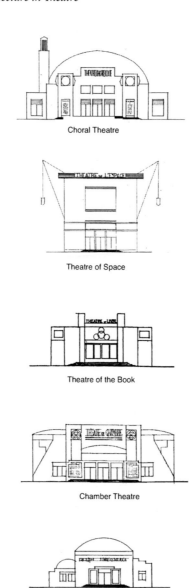

Choral Theatre

Theatre of Space

Theatre of the Book

Chamber Theatre

University Theatre

FIGURE 6.1 *Façades of the five theatres drawn by Autant (Courtesy: Corti Press)*

DOI: 10.1057/9781137368683

that mark the city to give it a symbolic as well as physical structure. In contrast, the projection screen on the façade of the Theatre of Space is neither lofty nor monumental, its suspended counterweights almost comical. The Theatre of the Book and the Chamber Theatre have rectangular façades that imply a position along streets as part of the urban fabric. The five buildings together suggest the character and scale of a city that is inhabited at many levels and many depths to create a sociable, collective experience.

Esprit de système

Autant and Lara envisioned a society centered on artistic inspiration, cooperation, and open discussion. All people would participate. To watch would be to learn, so that one might speak and act as part of collective society.³ In theatre, Art et action performed the mythic stories of the society that they dreamed would come. Autant designed performance spaces that modeled how the architecture of the new society might give people appropriate positions from which they could watch, learn, and act.

Looking back on Autant and Lara's work from a comfortable historical distance, its vision of collectivist urbanism seems compelling yet replete with irony. The participatory drama that they sought but only fleetingly achieved had already been appropriated for propaganda in Soviet Russia. The Blue Blouse agit-prop theatre staged in public squares of small towns throughout the countryside during the 1920s was designed to rally uneducated townspeople to a Communist political philosophy that ultimately led to state control of their livelihoods and lives. In the 1930s, as revolutionary communism became Stalinism, the mass parades and celebrations along Gorky Street in Moscow became mandatory, draining them of joy.⁴ The well-ordered society of the people stiffened into a jailhouse and the dream of creative freedom that had drawn European artists to Marxist political philosophy in the first place was denied.

From our historical vantage point, Autant's systematic thinking—his *esprit de système*—also seems to undercut itself. The five theatres proposed categories of human interaction that were more invented than observed. His tidy artistic bureaucracy defined the social qualities of the theatres to contrast with one another along specific axes: audiences were popular

DOI: 10.1057/9781137368683

or scholarly; interactions were introspective or outward-looking. Both distinctions imply a social hierarchy that inexorably assigns certain roles to certain people, even if an individual's status was based on a "calling" or "artistic inspiration." To take these divisions too seriously would be frightening, if not absurd.

Autant's categorical thinking, however, offers a compelling avenue of speculation. By abstracting aspects of quotidian life, grouping them, and then following the logic of each group to its extreme, we begin to imagine the spatial qualities associated with particular kinds of interaction. The performance spaces of Autant's theatre buildings define axes of logical contrast (Figure 6.2). Each characteristic finds its opposite in another theatre; for example, the Choral Theatre is designed for auditory performances and has no windows, sealing the event away from the outside and enclosing the audience as a group, so the only universe was the sonic atmosphere of spiritual voices that auditors heard together. At the other extreme, the Theatre of Space has windows on all sides of the performance space to bring natural light in and allow views to the landscape and the sky beyond. Performances were primarily visual and linked the experience of the city to the inspiration of art, which looked outward to the universe.

The Theatre of the Book addressed academic audiences and separated word from image. Performances grouped students together in classes in which they could discuss tableaux they saw and poetic text they heard. Their commentary joined that of characters in the play, readers, and other classes in a layered space that multiplied the thresholds between pure performance and pure watching. Chamber Theatre held the other extreme in performances intended for popular audiences. Word and image flowed seamlessly together in intense, intimate scenes. Conversation, however, would be impossible. In place of multiple layers of space and commentary, spectators watch with no distractions, and an impassible gulf between them and the scene, so they experience the story personally and vicariously.

The University Theatre recombined some of the spatial qualities of the other theatres to shuffle opposing characteristics. The building opened to the town and to the sky, suggesting that it was a public space engaged with everyday life, yet audiences were limited to the academic community. Conversation was central to the performance yet was defined as debate that would be watched by an audience, rather than generated in small groups among equals. The space and performance were

DOI: 10.1057/9781137368683

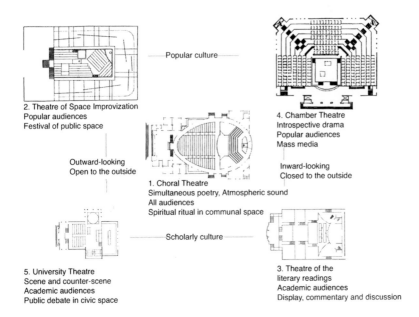

Popular culture

2. Theatre of Space Improvization
Popular audiences
Festival of public space

4. Chamber Theatre
Introspective drama
Popular audiences
Mass media

Outward-looking
Open to the outside

Inward-looking
Closed to the outside

1. Choral Theatre
Simultaneous poetry, Atmospheric sound
All audiences
Spiritual ritual in communal space

Scholarly culture

5. University Theatre
Scene and counter-scene
Academic audiences
Public debate in civic space

3. Theatre of the
literary readings
Academic audiences
Display, commentary and discussion

FIGURE 6.2 *Diagram of the plans of Autant's five theatres in matrix based on his descriptions of the audience and type of drama (plans drawn by Autant, placed in matrix by author)*

hierarchical and scholarly, yet outward-looking, so spectators retained a visual connection to the city.

As a type the University Theatre culminates the sequence started by Chamber Theatre. Some of its qualities seem to reflect back on the origins of all the theatrical types. Both University and Chamber theatres center on the human voice—one on choral poetry, the other on reasoned speech. In the Choral Theatre, voices are supported by music from an orchestra behind them, so the words are figures in a sonic atmosphere. In the University Theatre, debates are framed against a library that rises behind them, so words are spoken as if in conversation with the cumulative knowledge of the past—an atmosphere of many voices. The two forms of theatre in their respective milieux represent the poles of vocal expression in performance, ultimately speaking to each other to bring the categories into a clear relationship.

Charted according to their similarities and differences, the five theatres map a field of architectural and social potential. They peg the extreme limits, like the survey marks a cartographer sets to anchor an area for

DOI: 10.1057/9781137368683

investigation. In this sense Autant and Lara's system can be seen as a game of logic, which sets up artistic inquiry by projecting among points. Each combination of characteristics might open unforeseen spatial, social, or performance possibilities.

The theatre buildings can be read not only as architectural projects in themselves but also as expositions of ideas that suggest territory for creative thought in architectural action. The logic play that Autant and Lara enjoyed betrays a modern sense of abstraction, with each quality begging its opposite. The game of speculation, like theatre itself, stands removed from real-world exigencies to open a field of conjecture where the terms are defined in performance. The invitation to the game has remained open for more than fifty years.

The trajectory of tradition

In the broad sweep of tradition, Art et action's performances reclaimed the ancient role of theatre as something integral to the social life of the city yet also set apart from it. Greek theatre performances opened a space for narrative that allowed those who participated to make spiritual contact with the eternal world of the gods and with each other. This space, or *chora*, created by the dance of the chorus opened a view to the alternate place and time of the story.[5] Spectators came together to watch as part of a spiritual ritual, which stood at some distance from everyday material life to avoid risk of contamination, yet was crucial to melding a community.

Art et action's work also adhered to the Baroque tradition in which urban spaces and buildings were considered the stage sets for the events of social life, so much so that the art of architecture and theatre overlapped.[6] Well into the twentieth century, European cities continued to emphasize the theatrical in all aspects of life, and the tradition still guided the teaching at the École des Beaux Arts, where Autant and Perret studied together. The identification of architecture as stage set for events had retreated, however, in the development of modern thought, initially under the influence of seventeenth-century rationalism which reduced space to axial dimensions and subsequently, in response the leading modern architects of the twentieth century, who defined space principally in terms of geometrical composition and light. Even thus reduced, some among the modernists continued the tradition of architectural

DOI: 10.1057/9781137368683

mise-en-scène. With a design palette stripped of illusion and extraneous detail, they focused on fundamental geometry not of visual composition but of human interaction. In the parallel realm of theatre, Autant mapped out in set design the geometry of spatial relationships.

Autant and Lara practiced architectural theatre at the last possible moment in the trajectory of the classical tradition of *mise-en-scène,* when much was already faltering in the din of the times. The ideologically charged atmosphere of 1930s Europe, World War II, and the Cold War that followed had no room for subtlety, and even less for play. The socialist Popular Front, which mounted the Exposition in Paris of 1937 and built Autant's Theatre of Space, lost power that same year. The rapid descent into war, the occupation of Paris, and the subsequent rush to rebuild overwhelmed the contemplative approach to architecture implicit in Autant's work. By the time Art et action published its compilation *Cinq conceptions de structures dramatiques modernes* (*Five Conceptions of Modern Dramatic Structure*) in 1956, the arts of both architecture and drama had shifted considerably, rendering the work dated if not irrelevant.

They never gained the audience or artistic recognition that they might have hoped, even as they insisted that true art did not require such temporal rewards. They practiced liberty, holding fast to a vision of how things might or should be in a more perfect collectivist society, and to the role of artists to transform both the spirit and reality of a possible future. On several occasions, a reminder of the tone of their mission appeared on programs for performances, "all joy that does not elevate the individual or the collective is almost an involuntary humiliation," a phrase that intimates in a double negative the urgency and paradox of their effort.[7]

After World War II, the West hardened against ideas associated with Communism, including any that celebrated collective social life. The emerging definition of a modern public realm tended toward vast spaces for mass spectacle rather than the more socially interactive spaces that Autant and Lara explored. Theatrical performances also turned to large audiences and took the form of huge, commercial productions or cinema. Experimental theatre, on the other hand, retreated into tiny, windowless, black box theatres. Although this gave rise to innovative staging configurations, it also restricted contact with the world outside the theatre and closed down any meaningful, spatial link between the performance and the city. The long Cold War shifted the mood so thoroughly that the

DOI: 10.1057/9781137368683

metaphor of theatrical urban life faded in the glow of media spectacles and the headlights of cars that had taken over the city's streets.

The ebb and flow in modern interest in the tradition of *theatrum mundi* parallels the popularity of Henri Bergson's ideas, which had inspired Apollinaire and all of the artists associated with Art et action. In the 1910s and '20s Bergson had been wildly popular, speaking to large crowds in both academic and popular venues. His validation of intuition and the notion of an *élan vital*, or life force, that drove both biological evolution and human intellect supported the idea of spiritual progress in both art and humanity. By the 1930s, however, attention had turned to the more materialist phenomenology of Edmond Husserl and Martin Heidegger in Germany and Maurice Merleau-Ponty in France, recasting Bergson's ideas as flaccidly romantic.[8] By the 1950s, Bergson was all but forgotten. In the 1960s, Gilles Deleuze and Felix Guattari reread his work to find a philosophy of life and change grounded in biological evolution rather than physics. Dropping Bergson's spiritual overtones, they developed an ecological philosophy that focused on relationships rather than essences. They described all things as emergent and changing assemblages of multiple elements that are themselves assemblages. Deleuze and Guattari's ideas contributed to a vibrant strain of post-modern philosophy that continues to influence art and architecture today.

Autant and Lara's endeavors in theatre carried Bergson's ideas as well as the larger tradition of *theatrum mundi* and were likewise passed over by the younger generation of modernists in the 1950s and '60s. Yet they continued to work, Autant into his 90s, with the assistance of Lara's niece, Marie-Antoinette Allèvy who took the name Akakia-Viala.[9] Autant persisted, carrying a tradition of thought from the nineteenth century past World War II into a vastly changed intellectual milieu. Ultimately, he survived almost long enough to see at least part of the philosophical tradition that he embraced emerge reformulated in the work of others.

In the 1960s, French critic Guy Debord argued that the vital, participatory drama of the city had been seriously eroded by modern media spectacles, which by separating actors from audience had rendered spectators mute, passive, and anonymous.[10] He wrote, "It is the opposite of dialogue."[11] In a livid Marxist critique, he condemned spectacle as the siren of capitalist modernity that lures people away from each other and from the reality of their own existence: "From the automobile to television, all the goods selected by the spectacular system are also its weapons for a constant reinforcement of the conditions of isolation of

DOI: 10.1057/9781137368683

'lonely crowds.'"[12] "Separation," he maintained, "is the alpha and omega of the spectacle."[13] Debord argued that spectacle substitutes image for substance, the virtual for the material, draining away the sustaining, emotional life of the community.

Debord's outcry implicitly elevates participatory drama, despite its coercive use as a tool of propaganda in Soviet Russia. In the 1960s Debord gathered a group of writers and artists under the banner of the Situationist International movement, to advocate radical artistic freedom and play. Artists created not autonomous works of art but situations designed to intervene poetically and politically in the habits of daily life. The group embraced the artistic games of the Surrealists and envisioned the city as an open territory for experimentation in which citizens could wander and build as their imaginations led them. Artist and architect Constant Nieuwenhuys (known as Constant) proposed a city of endless play, New Babylon, which rode above the old city of work. In a roving world of endless artistic possibility, private space was eliminated and the public realm was expanded as a zone of free invention.[14] Participatory theatre would erupt spontaneously as the collective spirit moved the city's inhabitants.

During the late 1960s, Debord's ideas contributed to an atmosphere of rebellion. In 1968 students in Paris demonstrated against the rigid structure of the university system that confined their imaginations in the fetters of a classical curriculum. In particular, a group of young architecture students marched in protest of the moribund classicism taught at the École des Beaux Arts. They advocated modern architecture, using the same language of protest that progressive architects in the 1920s had used to criticize the same Beaux Arts classicism. However, the cry of 1968 championed the tradition of urbanism allied with theatre, which had simmered in the background of the Modern Movement since the 1930s. The demonstrations themselves took the form of street theatre, advocating a free artistic and social life in the city. Constant wrote, "the teenage revolt against the fossilized standards and conditions of the past is aimed chiefly at the recovery of social space—the street—so that the contacts essential for play may be established."[15] This ebullient spirit fed numerous radical proposals by young architects, particularly at the Architectural Association in London. Peter Cook of Archigram, Wolf Prix of Coop Himmelblau, Rem Koolhaas, and Bernard Tschumi all drew and wrote playfully and extensively as young architects, long before building a building.

DOI: 10.1057/9781137368683

Among the most influential and most relevant to this inquiry, Tschumi articulated a theoretical structure that draws on strategies from both theatre and cinema to design buildings that invite multiple, spontaneous urban events.[16] "There is no architecture without event." Tschumi also draws on Deleusian ideas of multiplicity to describe architectural pleasure as an almost erotic experience that is part performance, part bodily immersion, and part intellectual interpretation. He sought out the cinematic techniques of prewar Russian filmmaker Sergei Eisenstein as a model for the design of architectural experience, focusing on montage, a way to construct a story by juxtaposing multiple quick shots, as if in a spatial field.[17] Eisenstein learned his craft at the feet of Vsevolod Meyerhold, the pioneer of modern theatre. In receiving this intellectual tradition and putting it to use in design, Tschumi writes, "[A]rchitecture is not only what it looks like but what it does."[18]

Fifty years before the revolt at the École des Beaux Arts, Edouard Autant stopped designing buildings so that he could pursue architecture. In theatre, he designed spaces that spoke in stories, which connected people to each other and to the larger web of ideas and emotions that reach deep into Western tradition. He devised architecture as a player that acted in theatre on behalf of the places that people inhabit everyday in the city and demonstrated how it might act in a more perfect world. In plays that he wrote, Autant often cast the architect as a hero, whose works represent the essence of human endeavor. Autant, Louise Lara, and a changing cast of willing players improvised spatial sets and performances in a small loft theatre in Montmartre. Their venue was Paris, the city in the midst of a debate on the urban definition of modernism. Their work was not widely seen or imitated and stood apart from that of the avant-garde. Yet they persisted in a systematic way to explore the actions of space and the spaces of watching. They advanced a tradition of architectural thought that remains rich with potential.

Notes

1 This well-known quote was originally published in: Pierre Reverdy (1918) "L'Image," *Nord-Sud*, 13/May, n.p.
2 Filarete's treatise in particular exemplifies classical town planning. See Antonio Di Piero Averlino (1965 (1464)) *Filarete's Treatise on Architecture: Being the Treatise by Antonio Di Piero Averlino, Known as Filarete*. *The*

DOI: 10.1057/9781137368683

translation, Volume 1, trans. John R. Spencer (New Haven: Yale Publications in the History of Art).

3 The long essay on University Theatre specifies an education based in theatre in which students watch and act as a way of learning.

4 Castillo, "Gorky Street and the Design of the Stalin Revolution."

5 Alberto Perez-Gomez (1994) "Chora: The Space of Architectural Representation," in Alberto Perez-Gomez (ed.), *Chora 1* (Montreal: McGill-Queen's Press), 1–34 p. 10.

6 Perez-Gomez, *Built Upon Love* p. 59. See also Richard Sennett (1977) *The Fall of Public Man* (Cambridge: Cambridge University Press).

7 Art et action, "Le Théâtre universaire."

8 Edmond Gustav Albrecht Husserl, German philosopher, mathematician and founder of the twentieth-century school of phenomenology (1859–1938). Maurice Merleau-Ponty, French phenomenological philosopher influenced by Martin Heidegger and Husserl (1908–1961).

9 Marie-Antoinette Allévy or Akakia Viala, actress and scholar of theatre, dates unknown.

10 Guy Debord, French Marxist theorist, writer, filmmaker and founding member of Situationist International (1931–1994).

11 Guy Debord (1977 (1967)) *The Society of the Spectacle*, trans. Fredy Perlman and John Supak (Detroit: Black & Red). also available online: http://www.marxists.org/reference/archive/debord/society.htm

12 Debord, *The Society of the Spectacle*, 1:28.

13 Debord, *The Society of the Spectacle*. 1:25.

14 Constant Nieuwenhuys or Constant, Dutch painter, sculptor, writer, and architect (1920–2005) See Mark Wigley (1989) *Constant's New Babylon: The Hyper-Architecture of Desire* (Rotterdam: 010 Publishers).

15 Constant Nieuwenhuis, "New Urbanism" (The Friends of Malatesta, Buffalo NY, 1970) http://www.notbored.org/new-urbanism.html. First published as "Nieuw Urbanisme" *Provo #9* (May 12, 1966).

16 Bernard Tschumi (b. 1944) Swiss architect and theoretician who has been broadly influential.

17 Sergei Eisenstein (1898–1948) Russian film director and theoretician who developed the montage technique.

18 Bernard Tschumi (2012) *Red Is Not a Color* (NY: Rizzoli International) p. 41.

DOI: 10.1057/9781137368683

Bibliography

Abel, Richard (1988) *French Film Theory and Criticism: 1907–1939* (Princeton: Princeton University Press).

Affron, Matthew (2013) "Contrasts of Colors, Contrasts of Words," in Leah Dickerman (ed.), *Inventing Abstraction, 1910–1925* (Museum of Modern Art), 82–93.

Apollinaire, Guillaume (1914) "Simultanisme-Librettisme," *Les Soirées de Paris*, 25.

—— (1972) "Modern Painting," in Leroy C. Breunig (ed.), *Apollinaire on Art: Essays and Reviews 1902–1918* (NY: Viking Press).

Aristotle (2000) *Politics*, trans. Benjamin Jowett (NY: Dover).

Aronson, Arnold (1977) *The History and Theory of Environmental Scenography* (Ann Arbor: UMI).

Art et action (1938) "Le Théâtre choréique," *Architecture d'aujourd'hui*, 9 (9), 40.

—— (1952) *Cinq conceptions de structures dramatiques modernes*, 13 parts in one volume vols. (Paris: Corti).

—— (1952 (1930)) "Cours de comédie spontanée moderne (4e année) Du syllogisme au dilemme," in Art et action (ed.), *Cinq conceptions de structures dramatiques modernes* (Paris: Corti).

—— (1952 (1931)) "Le Théâtre du livre," in Art et action (ed.), *Cinq conceptions de structures dramatiques modernes* (Paris: Corti).

—— (1952 (1932)) "Le Théâtre de chambre," in Art et action (ed.), *Cinq conceptions de structures dramatiques modernes* (Paris: Corti).

DOI: 10.1057/9781137368683

—— (1952 (1933)) "Le Théâtre universaire," in Art et action (ed.), *Cinq conceptions de structures dramatiques modernes* (Paris: Corti).

—— (1956 (1929)) *Cours de comédie spontanée moderne* (1e, 2e et 3e année) technique et réalisations," in Art et action (ed.), *Cinq conceptions de structure dramatiques modernes* (Paris: Corti).

—— (n.d.-a) *Synesthesie*, (Paris: Fond Art et Action, Archive des Arts du Spectacle, Bibliothéque Nationale de France).

—— (n.d.-b) *Gulliver au pays de nains et au géants*, Fond Art et Action, Archive des Arts du Spectacle, Bibliothéque Nationale de France (Paris).

—— *Théâtre de l'espace* Folio 27, Fond Art et Action, Archive des Arts du Spectacle Bibliothéque Nationale de France, Paris.

—— (n.d.) *Cain*, Fond Art et Action, Archive des Arts du Spectacle, Bibliothéque Nationale de France (Paris).

Art et action and Viala, Akakia (1925) *Micromegas*, Fond Art et Action, Archive des Arts du Spectacle, Bibliothéque Nationale de France (Paris).

Autant, Edouard (1915) *Paraboles des Corporations* (Stock & Co).

Autant, Edouard and Lara, Louise (1925) *La philosophie du théâtre*, Fonds Art et Action (Paris).

Autant-Lara, Claude (1984) *La rage dans le coeur: chronique cinématographique du 20e siècle* ([Paris]: H. Veyrier).

Averlino, Antonio Di Piero (1965 (1464)) *Filarete's Treatise on Architecture: Being the Treatise* by Antonio Di Piero Averlino, Known as Filarete. The translation, Volume 1, trans. John R. Spencer (New Haven: Yale Publications in the History of Art).

Baer, Nancy Van Norman (1991) *Theater in Revolution: Russian Avant-garde Stage Design 1913–1935* (San Francisco: The Fine Arts Museums of San Francisco, Thames & Hudson).

Barris, Roann (1998) "Culture as Battleground: Subversive Narratives in Constructivist Architecture and Stage Design," *Journal of Architectural Education*, 52 (2), 109–23.

Barzun, Henri-Martin (1912) *L'Ere du drame* (Paris: Figuiere & Cie.).

Bataille, Georges (1929) "Architecture," *Documents*, 2.

—— (1991) *Documents* (Paris: Jean Michel Place).

Becherer, Richard (2000) "Picturing architecture otherwise: the voguing of the Maison Mallet-Stevens," *Art History*, 23 (4), 559–98.

Bergson, Henri (1911) *Matter and Memory*, trans. Nancy Paul and W. Scott Palmer (London: George Allen & Unwin Ltd.).

DOI: 10.1057/9781137368683

—— (1919) "Introduction to Metaphysics," in Henri Bergson (ed.), *The Creative Mind* (NY: Greenwood Press), 187–237.

—— (1944 (1911)) *Creative Evolution* (NY: The Modern Library).

—— (1946) *The Creative Mind*, trans. Mabelle Andison (NY: Philosophical Library).

Blesser, Barry and Salter, Linda-Ruth (2009) *Spaces Speak, Are You Listening?* (Cambridge, MA).

Braham, William (2002) *Modern Color/Modern Architecture: Amadée Ozenfant and the Genealogy of Color in Modern Architecture* (London: Ashgate).

Britton, Karla (2001) *Auguste Perret* (London: Phaidon).

Bruzzi, Stella and Gibson, Pamela Church (eds.) (2000) *Fashion Cultures: Theories, Explorations, and Analysis* (London: Routledge).

Byron, George Gordon (1923 (1821)) *Cain: A dramatic mystery in 3 acts translated into French and refuted in a series of Philosophical and Critical Remarks by Fabre d'Olivet*, trans. Nayan Louise Redfield (London: G. P. Putnam).

Castillo, Greg (1994) "Gorky Street and the Design of the Stalin Revolution," in Zeynep Çelik, Diane Favro, and Richard Ingersoll (eds.), *Streets: Critical Perspectives on Public Space* (Berkeley, CA: University of California Press), 57–70.

—— (2001) "Socialist Realism and Built Nationalism in the Cold War 'Battle of the Styles'", *Centropa*, 1 (2), 84–93.

Colomina, Beatriz (1994) *Privacy and Publicity* (Cambridge: MIT Press).

Cooke, Catherine (1995) *Russian Avant-Garde: Theories of Art, Architecture and the City* (London: Academy Editions).

Corvin, Michel (1976) *Le Théâtre de recherche entre les deux guerres: Le laboratoire Art et Action* (Théâtre années vingt; Paris: La Cité-L'Age d'Homme).

Craig, Edward Gordon (1913) *Towards a New Theatre: Forty Designs for Stage Scenes* (London, Toronto: J. M. Dent & sons).

—— (1921) *The Theatre – Advancing* (London: Constable).

—— (1925) *Books and Theatres* (London: J M Dent & Sons).

—— (1960 (1911)) *On the Art of the Theatre* (New York: Theatre Arts Books).

Deauville, Max (1931) *Ecce Homo* (Paris: Editions du Murier).

Debord, Guy (1977 (1967)) *The Society of the Spectacle*, trans. Fredy Perlman and John Supak (Detroit: Black & Red).

DOI: 10.1057/9781137368683

Drexler, Arthur (1977) *Architecture of the Ecole des Beaux Arts* (NY: Museum of Modern Art).

Eisenstein, Sergei (1949) *Film Form*, trans. Jay Leyda (NY: Harcourt).

Foucault, Michel (1977) *Discipline and Punish* (NY: Pantheon).

Goethe, Wolfgang von (1951) *Goethe's Faust*, trans. Louis MacNeice (NY: Oxford University Press).

Gronberg, Tag (1998) *Designs on Modernity* (Manchester: University of Manchester).

Guicharnaud, Jacques (ed.), (1961) *Modern French Theatre from Giradoux to Beckett* (New Haven: Yale).

Harbeck, James (1996) "Okhlopkov and the Naissance of the Postmodern," *Theatre Insight*, 7 (1).

Herbst, Rene (1925) *Devantures et Installations de Magasins* (Paris: Moreau).

—— (1927) *Nouvelles devantures et magazines parisian* (Paris: Moreau).

—— (1929a) *Boutiques et magasins*, ed. Charles Moreau (Paris: C. Moreau).

—— (1929b) *Modern French Shopfronts* (London).

—— (1929c) "L'Étalage," *L'Encyclopédie des arts décoratifs* (Paris).

—— (1931) *Nouvelles devantures et Magasins: agencements de parisiens*, ed. Charles Moreau (Editions d'Art; Paris: C. Moreau).

Hicken, Adrian (2002) *Apollinaire, Cubism and Orphism* (London: Ashgate).

Hollier, Denis (1989) *Against Architecture: The Writings of Georges Bataille*, trans. Betsy Wing (October; Cambridge, MA: MIT Press).

Innes, C. D. (1972) *Irwin Piscador's Political Theatre: The Development of Modern German Drama* (Cambridge: Cambridge University Press).

Innes, Christopher (1993) *Avant Garde Theatre 1892–1992* (London: Routledge).

Jaeger, Werner (1945) *Paideia: The Ideals of Greek Culture*, trans. Gilbert Highet (2nd edn.; NY: Oxford University Press).

Jourdain, Francis (1954) "Preface," in Akakia-Viala (ed.), *Art et action, laboratoire de théâtre. Catalogue de la collection donnée à la Bibliothèque de l'Arsenal* (Paris: Bibliothéque nationale de France).

Kolesnikov, Mikhail (1991) "The Russian Avant-Garde and the Theatre of the Artist," in Nancy Van Norman Baer (ed.), *Theatre in Revolution* (San Francisco: Thames & Hudson, The Fine Arts Museums of San Francisco), 85–95.

Kovalenko, Georgii (1991) "The Constructivist stage," in Nancy Van Norman Baer (ed.), *Theatre in Revolution* (San Francisco: San Francisco Museum of Fine Arts, Thames and Hudson), 128–43.

DOI: 10.1057/9781137368683

Lara, Louise (1928) *L'Art dramatique russe in 1928* (Paris: Bergerac; imprimerie de la Lemeuse).

Lauroa, Marie-Christine, Beaumont-Maillet, Laure, and Colson, Jean (1992) *Dictionnaire des monuments de Paris* (Editions Hervas; Berkeley, CA: University of California Press).

Lawder, Standish (1975) *The Cubist Cinema* (NY: New York University Press).

Lefebvre, Henri (1991) *The Production of Space* (Cambridge: Blackwell).

MacGowan, Kenneth (1955) *The Living Stage* (NY: Prentice Hall).

Mallet-Stevens, Robert (ed.) (1929a) *Le Décor de la rue, les magasins, les étalages, les stands d'exposition, les éclairages*, 2nd Series (Paris: Editions Parade).

—— (1929b) "Le Décor moderne du cinema," *L'Art cinematographique*, 6.

Meyerhold, Vsevolod (1969) *Meyerhold on Theatre*, trans. E. Braun (NY: Hill & Wang).

Montaigne, Michel de (2010 (1910)) "Of Moderation," in William Carew Hazlett (ed.), *Essays of Montaigne* (6; NY: FQ Books).

Peacock, John (1982) "Inigo Jones' Stage Architecture and Its Source," *The Art Bulletin*, 64 (2), 195–216.

Penanrun, David de and Delaire, E. (1907) *Architect élèves de l'Ecole des beaux arts, 1793–1907* (Paris: Libraire de la Construction Moderne).

Perez-Gomez, Alberto (1994) "Chora: The Space of Architectural Representation," in Alberto Perez-Gomez (ed.), *Chora 1* (Montreal: McGill-Queen's Press), 1–34.

—— (2006) *Built Upon Love* (Cambridge, MA: MIT Press).

Perret, Auguste "Les Besoins collectifs et l'architecture," *Encyclopédie Française* (XVI; Paris), Section 68, page 7.

—— (1938) "Le Théâtre," *Architecture d'aujourd'hui*, 9 (9), 2–12.

—— (1952) *Contribution a une théorie de l'architecture* (Paris).

Perret, Auguste, et al. (2006) *Anthologie des écrits, conferences et entretiens* (Paris: Editions Le Moniteur).

Pinchon, Jean-François (ed.), (1990) *Rob. Mallet-Stevens: Architecture, Furniture, Interior Design* (Cambridge, MA: MIT Press).

Polti, Georges (1916) *Thirty-six Dramatic Situations*, trans. Lucille Ray (Boston: The Writer's Inc).

Reichlin, Bruon (1984) "The Pros and Cons of the Horizontal Windows: The Perret-Le Corbusier Debate," *Daidalos*, 13, 64–78.

Reverdy, Pierre (1918) "L'Image," *Nord-Sud*, 13 (May), n.p.

Roland, Romain (1920) *Liluli* (London: Boni & Liveright).

DOI: 10.1057/9781137368683

Sennett, Richard (1977) *The Fall of Public Man* (Cambridge: Cambridge University Press).

Solomon, Maynard (ed.) (1979) *Marxism and Art* (Detroit: Wayne State University Press).

Stewart, Susan (1993) *On Longing* (Durham, N.C.: Duke University Press).

Tairov, Alexander (1969) *Notes of a Director*, ed. H. D. Albright, trans. William Kuhlke (Books of the Theatre; Miami: Univ. of Miami).

—— (1974) *Le Théâtre libéré* (Paris: L'Age d'homme la cité).

Tonecki, Zygmunt (1932) "At the Boundary of Film and Theatre," *Close Up*, 9, 31–35.

Tschumi, Bernard (2012) *Red Is Not a Color* (NY: Rizzoli International).

Tschumi, Bernard and Chung, Irene (eds.) (2003) *The State of Architecture at the Beginning of the 21st Century* (Columbia Books of Architecture, NY: Monacelli Press).

Valery, Paul (1967) "Amphion," *Paul Valery Plays* (Paris: Gallimard).

Wigley, Mark (1989) *Constant's New Babylon: The Hyper-Architecture of Desire* (Rotterdam: 010 Publishers).

Wiles, David (2003) *A Short History of Western Performance Space* (Cambridge, UK: Cambridge University Press).

Yates, Frances A. (1969) *Theatre of the World* (NY: Barnes & Noble University of Chicago Press).

Yhcam (1912) "Cinematographie," *Ciné-Journal*, 191, 36–41.

DOI: 10.1057/9781137368683

Index

DOI: 10.1057/9781137368683

DOI: 10.1057/9781137368683

DOI: 10.1057/9781137368683

DOI: 10.1057/9781137368683

Lightning Source UK Ltd.
Milton Keynes UK
UKOW05n1537291113

222021UK00007B/2/P